Copyright 2013

Ron Koppelberger

Surreal Secret

Website
Wolffray.blogspot.com
Farthermostdream.blogspot.com

Dedicated to YOU!!!!!!!!!!!!

Welcome

I created this scrapbook of art to entertain the art enthusiast in you. These are in the shape of surreal dreams and thoughts. If you spend a few moments looking at them they will reveal themselves to you in the form of stories and sometimes hidden revelation. This is art that is meant to be looked at more than once……..Enjoy!!!

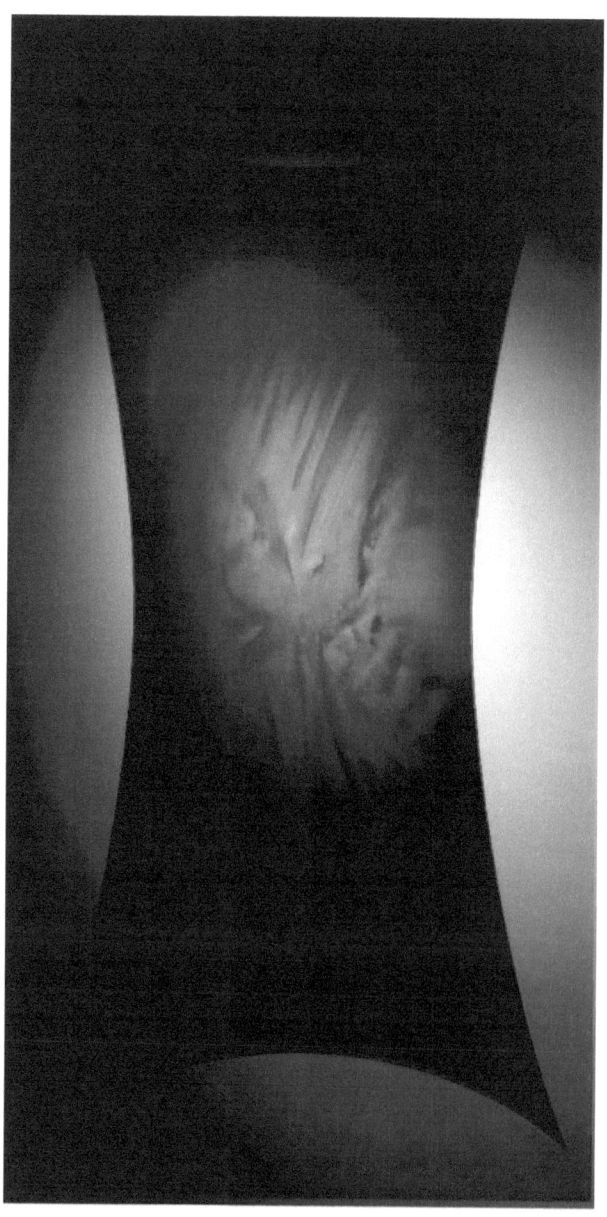

Lady Peacock In Black

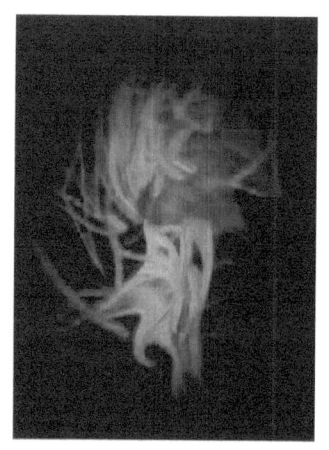

Angels In Red

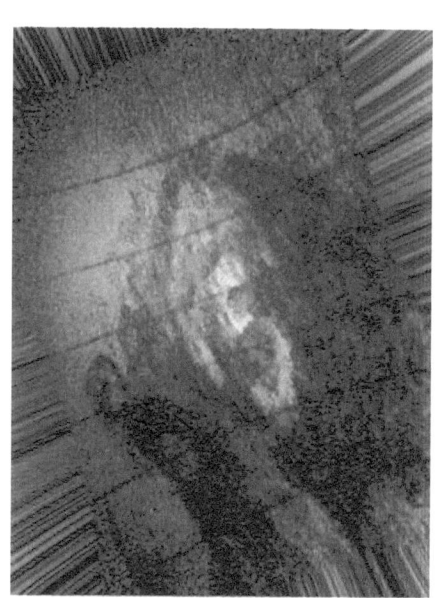

Woman In Misery and Contemplation

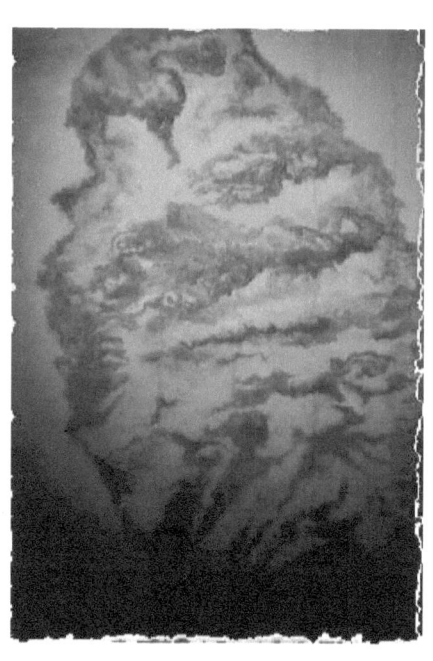

In Thought Crumbles

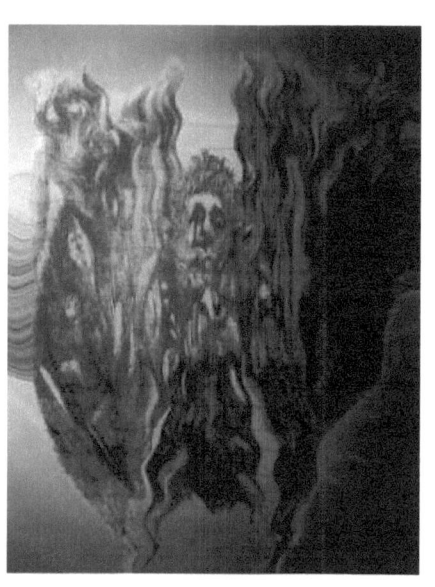

The Tears Of A Butterfly In Sorrow

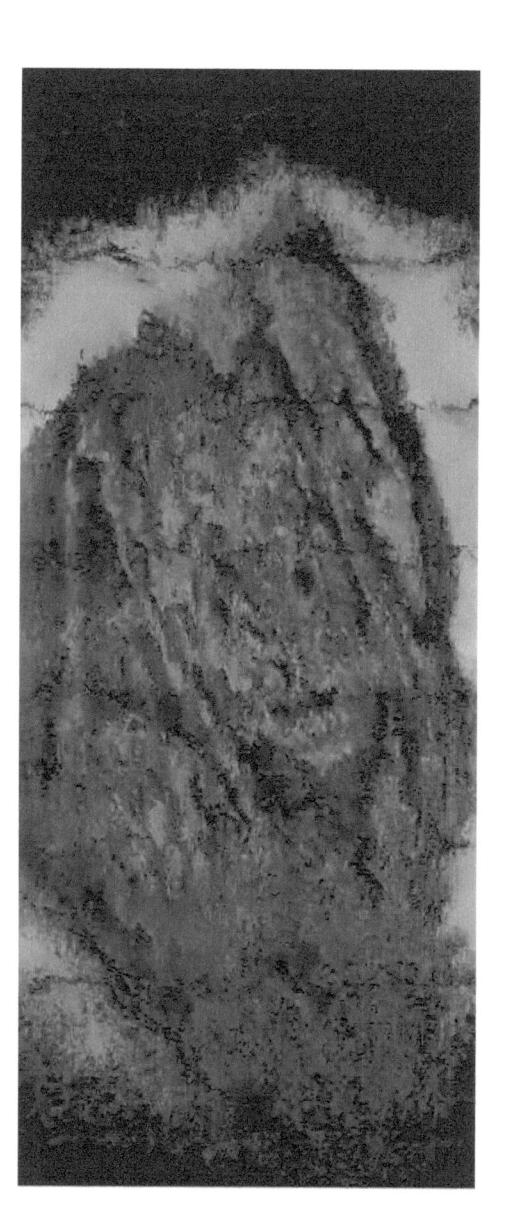

Escape To Avalon

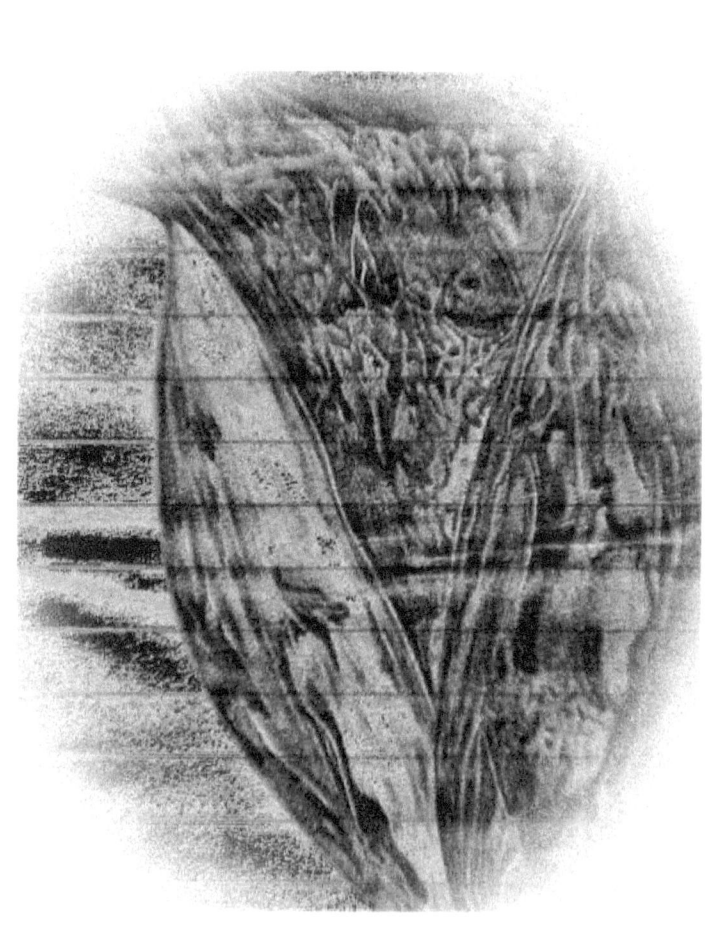

The Egg Hatching

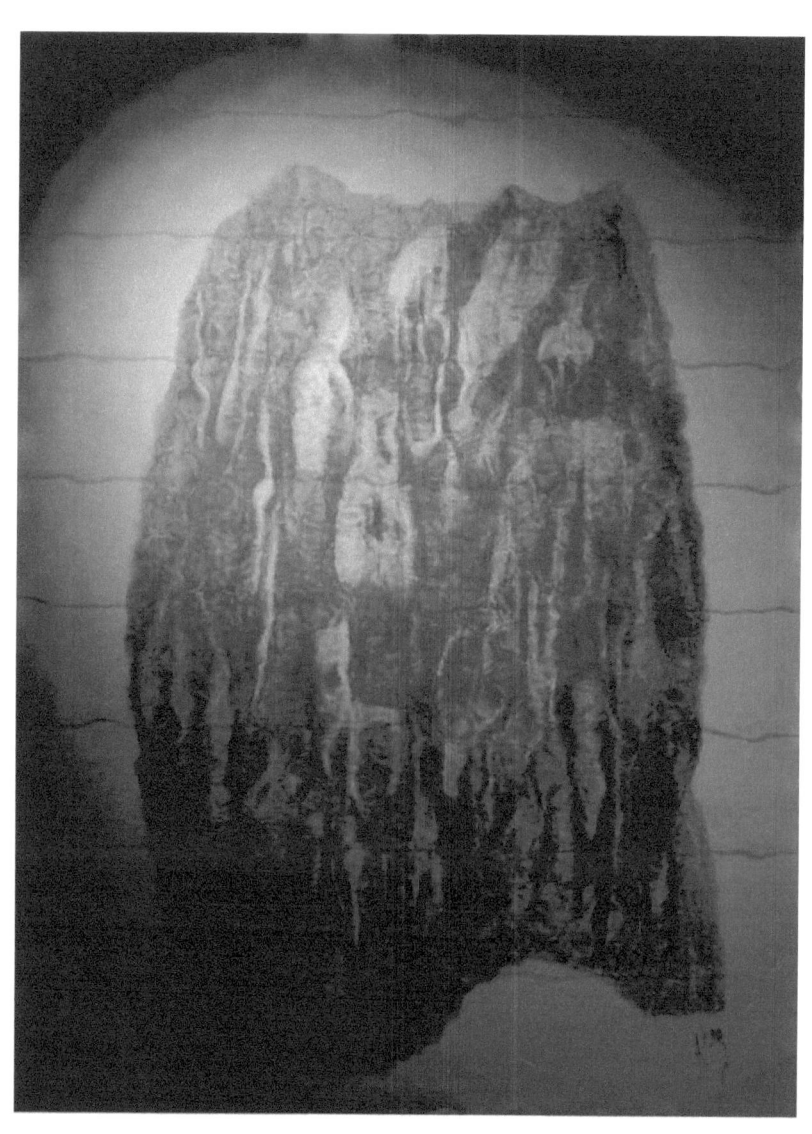

My World In Focus

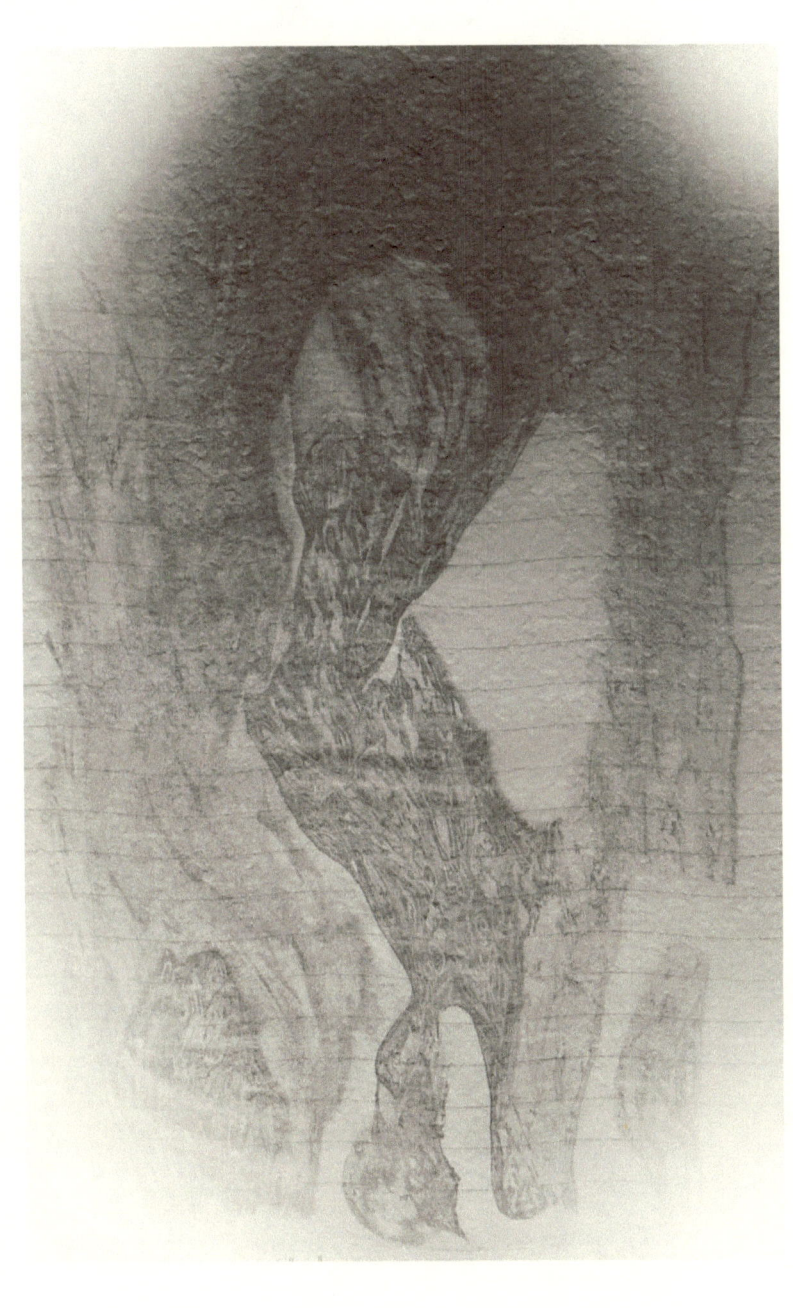

Woe In White

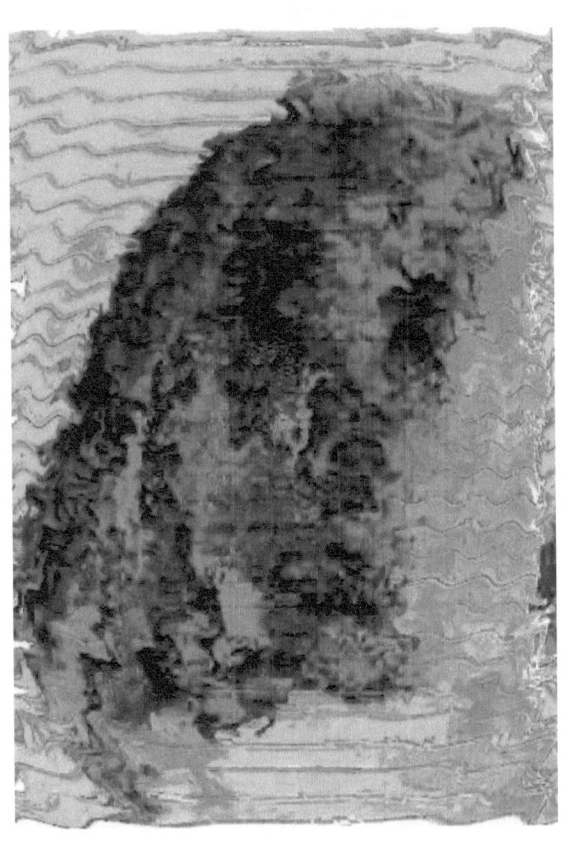

Her Flourish In Shadowy Light

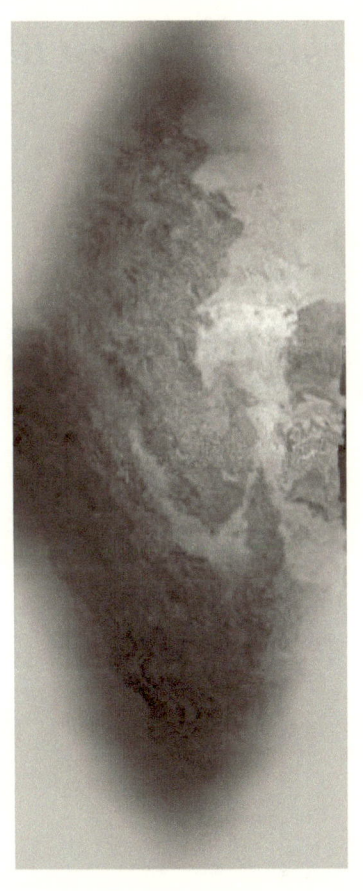

Praying In Earnest Blues

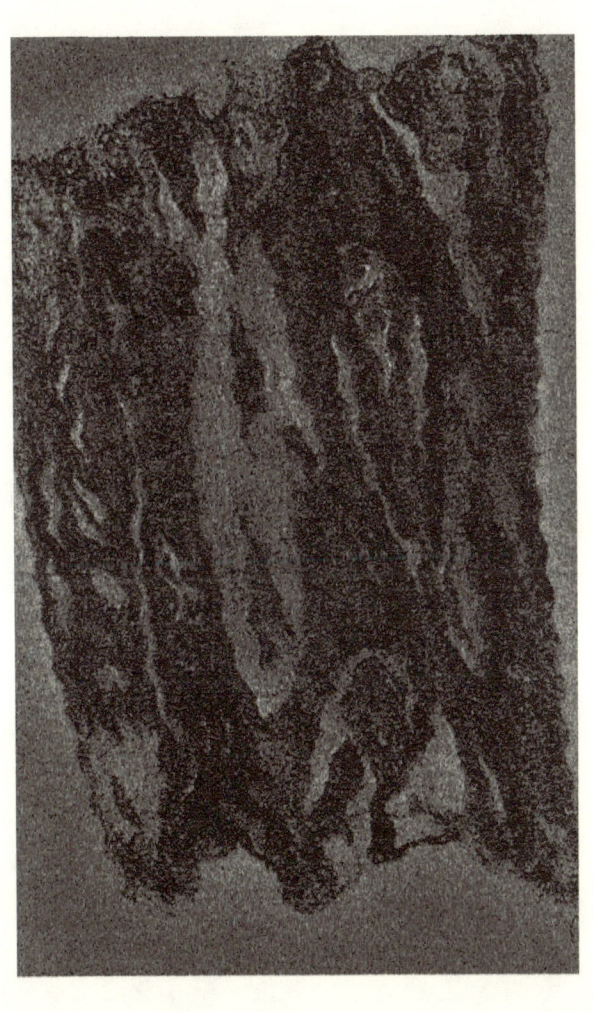

Images of a Dream In Tears

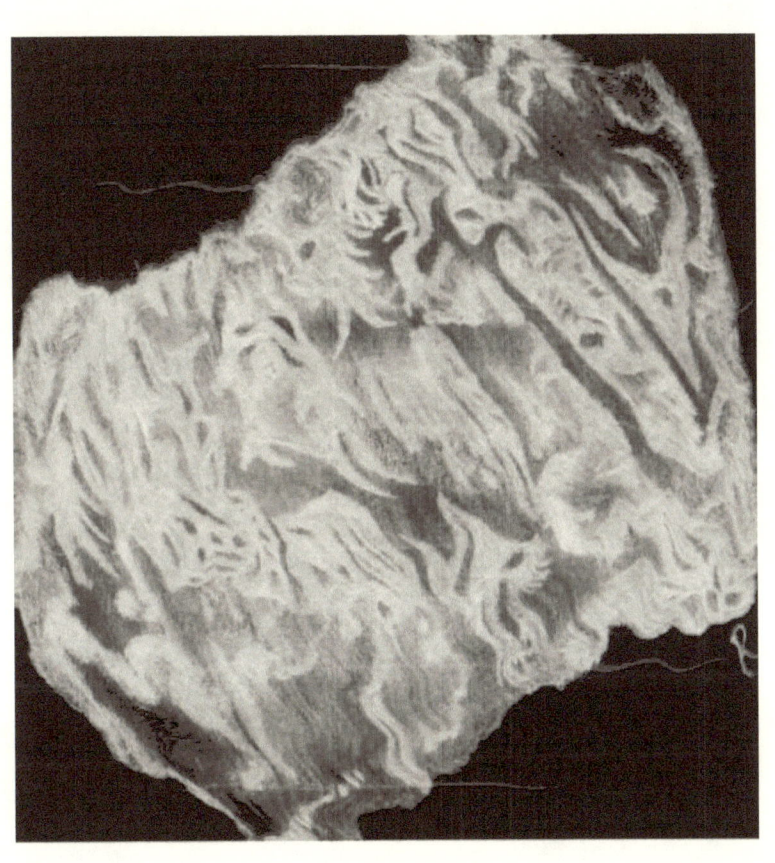

Everything In all And More

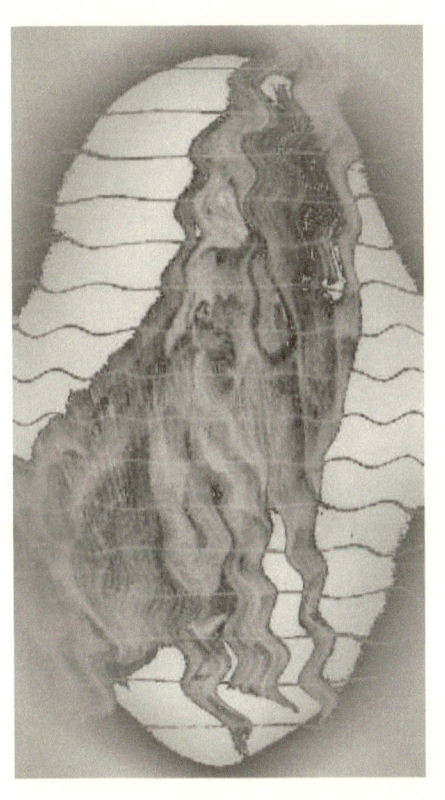

Dreamy Illusions

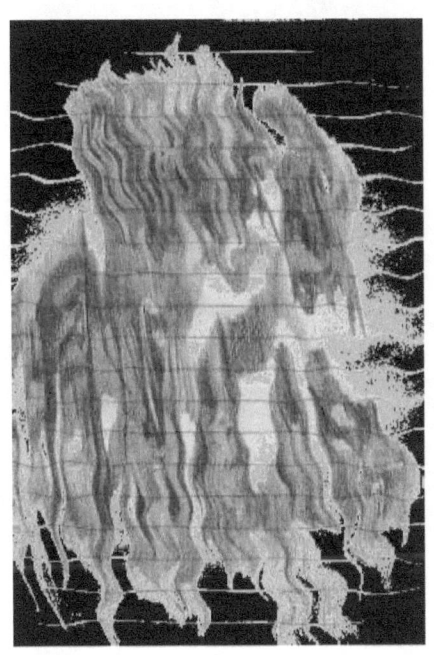

Nightmare In Motion

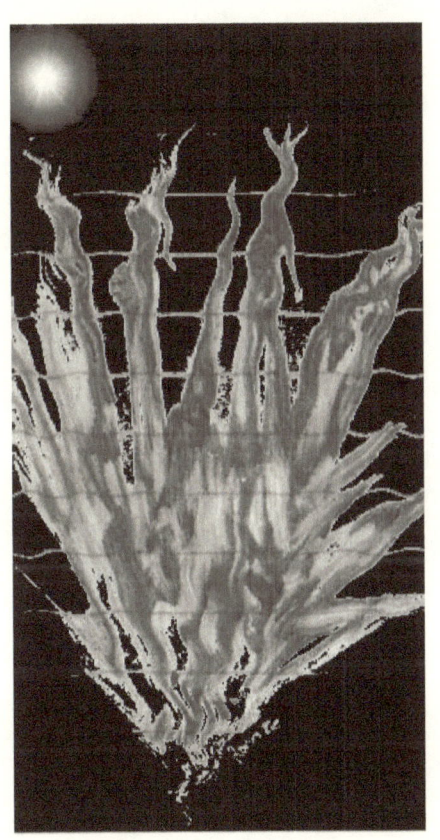

Weed In Cool Flame

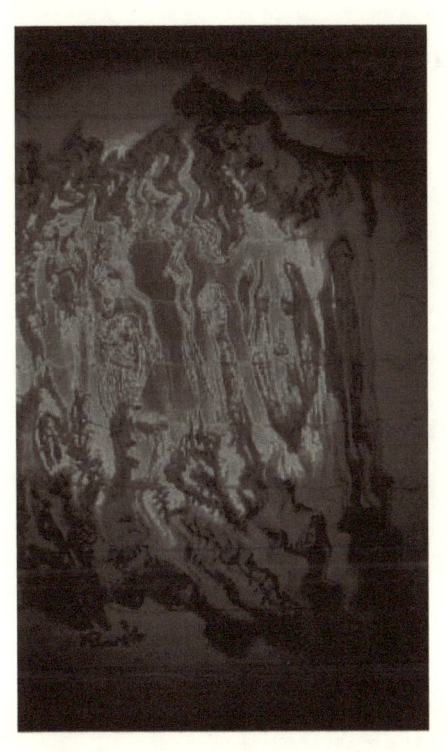

Peering Through The Flames of Perdition

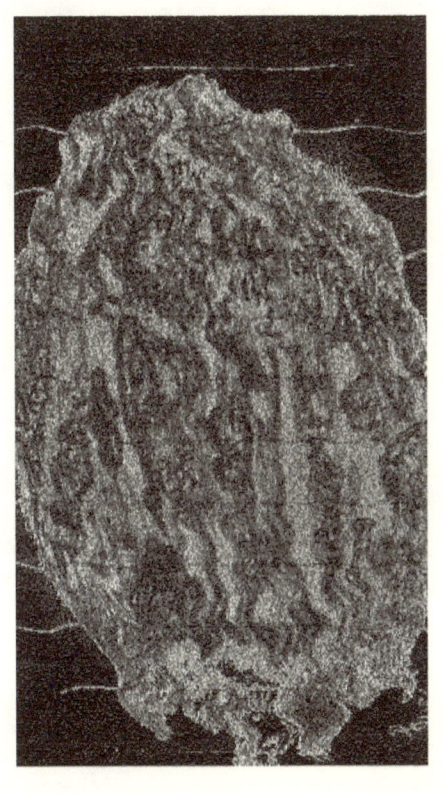

Faces and Shapes

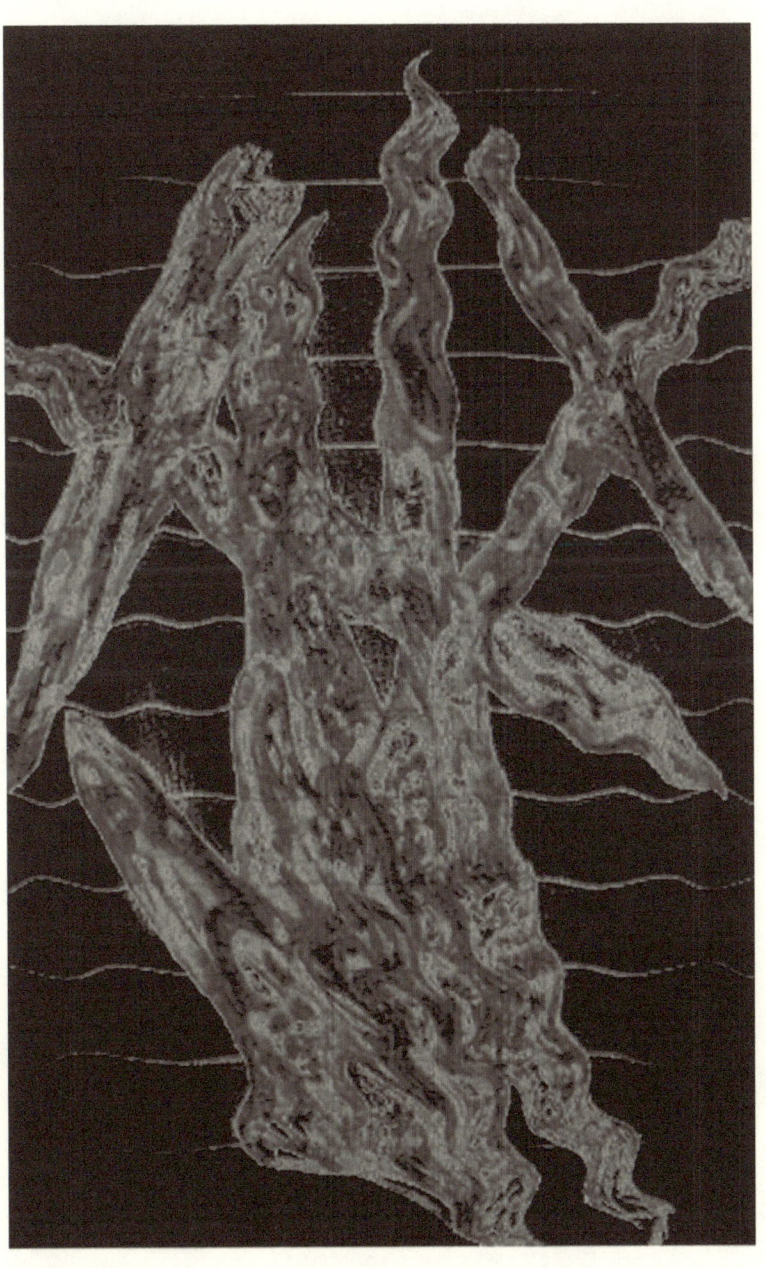

The Stork and Cross

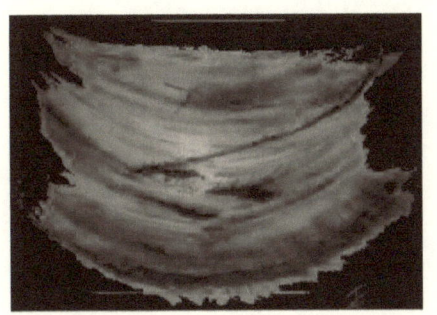

Madman On Fire

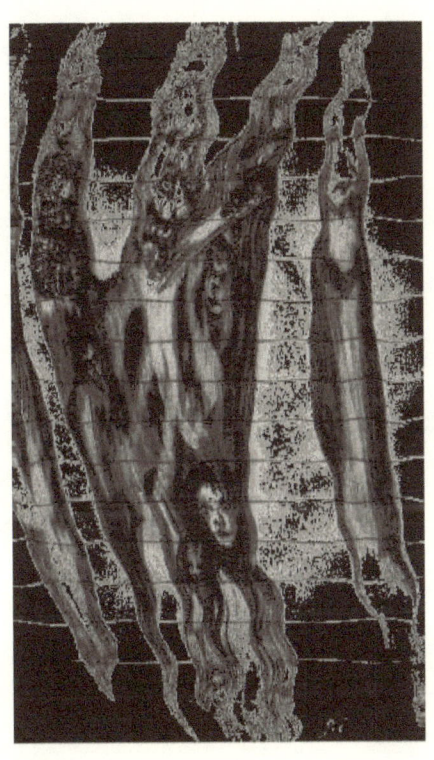

Lost In Thought And Dreams

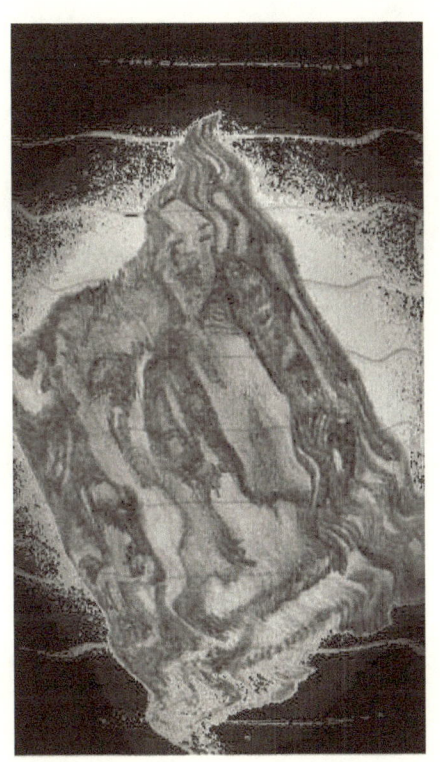

Baby Blue

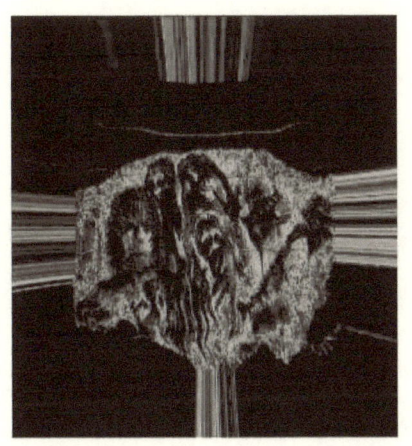

Angry In Perdition

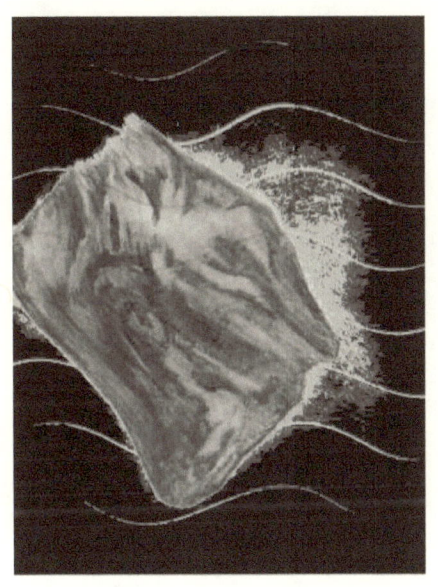

Ghosts In Her House

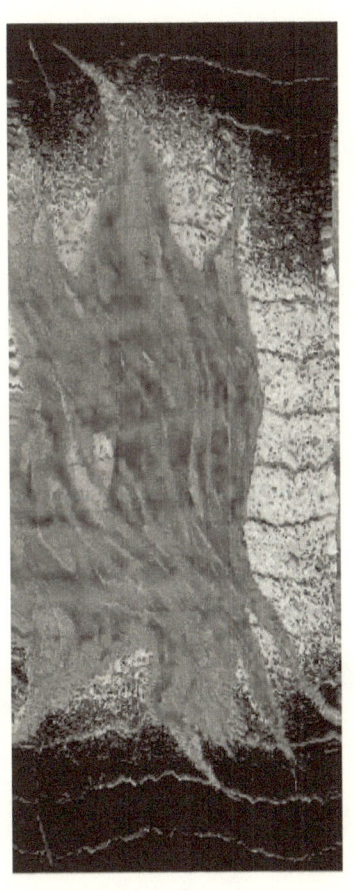

Dragon In Flame

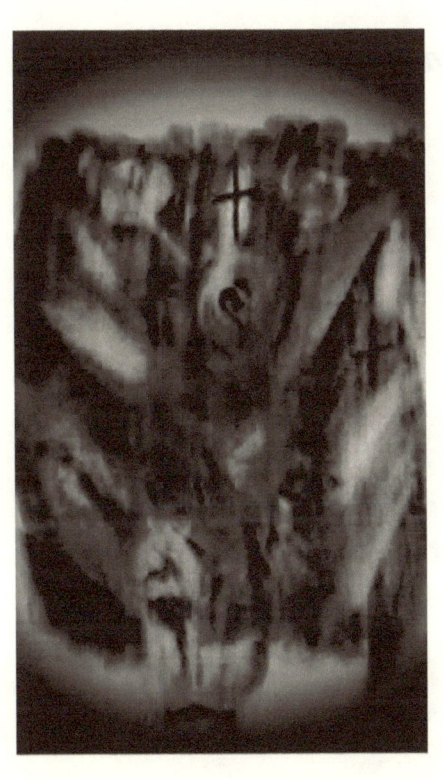

Images In My Mind and Light

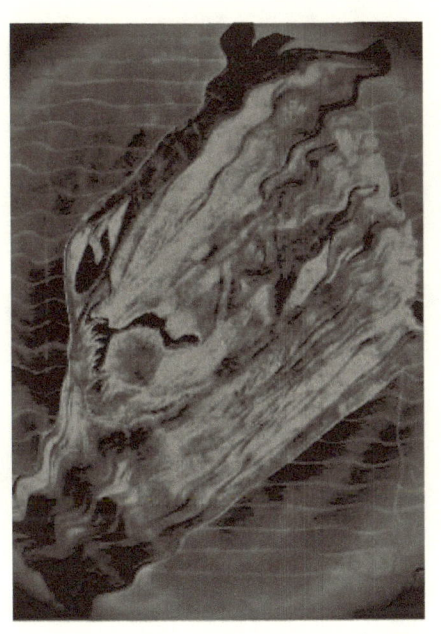

In Repose Within

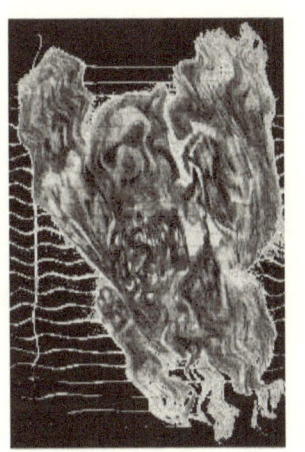

Bear In The Air

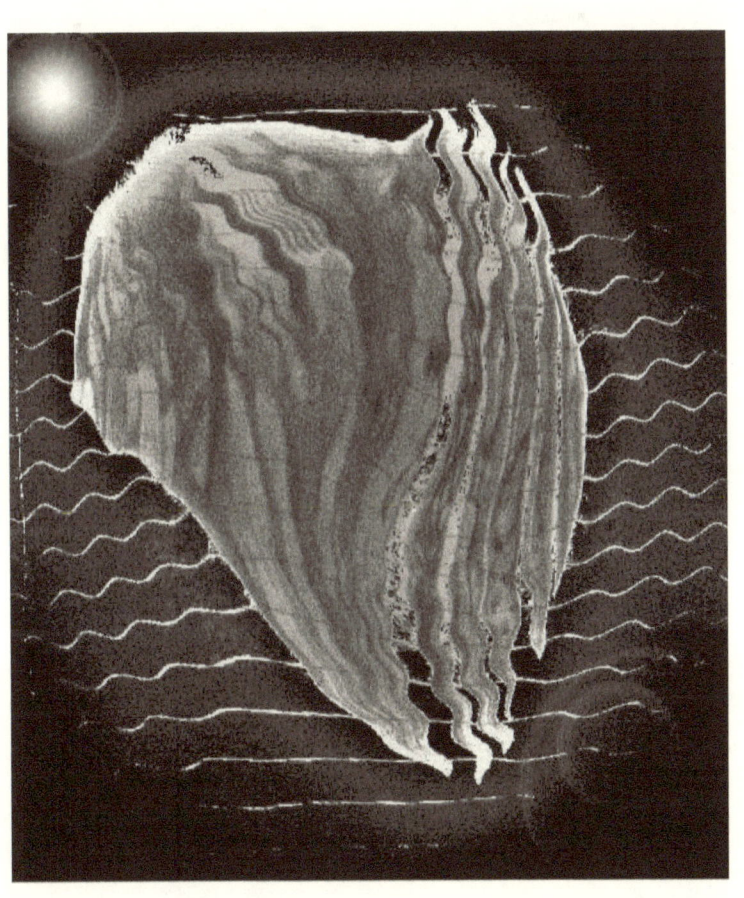

Slices Of The Sun

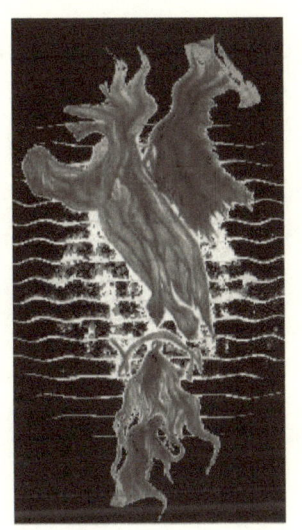

She Hides In Shadow

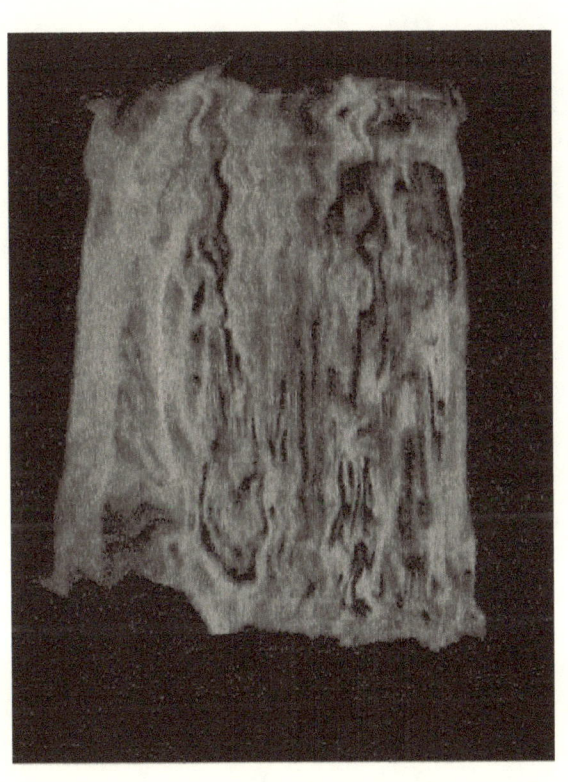

Horror In Crypts

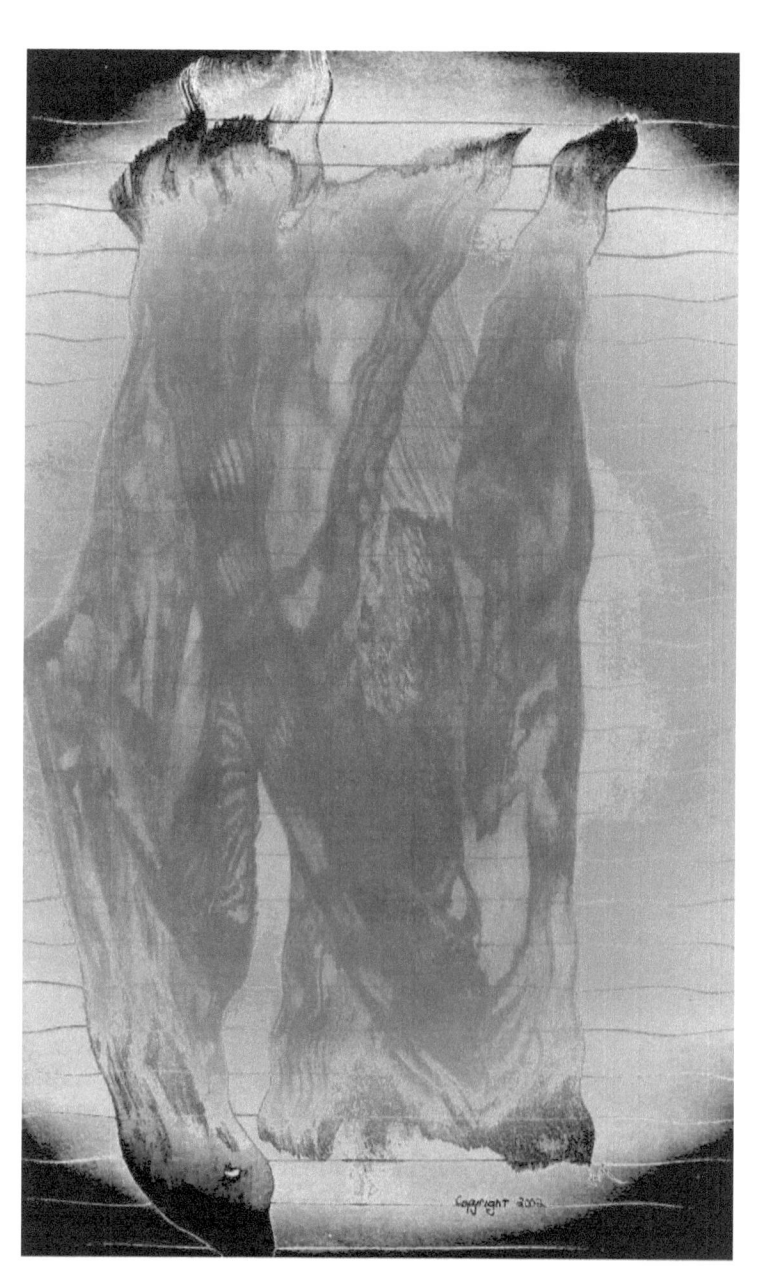

Butterfly In Gray

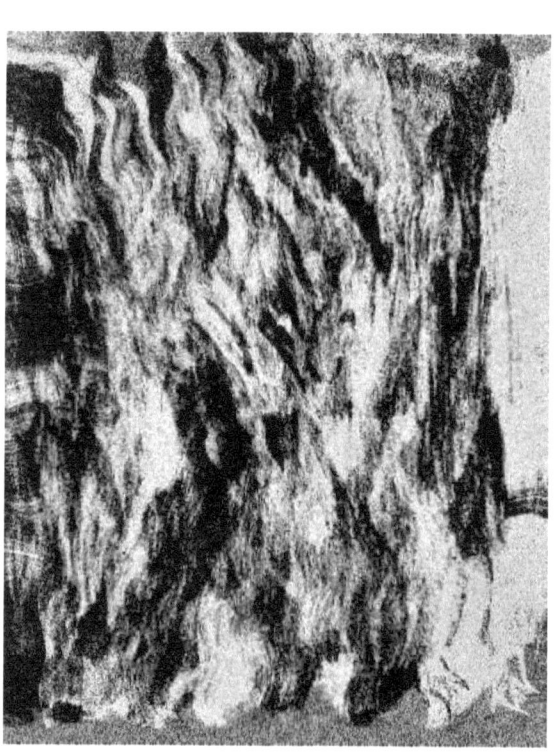

Monster and Motion

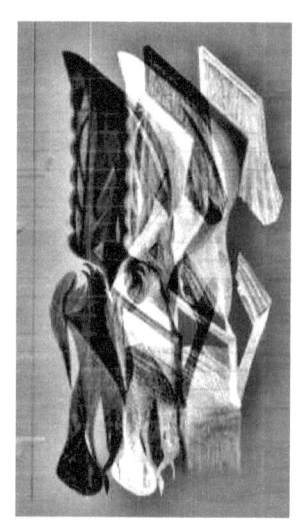

The Bird In Contrast

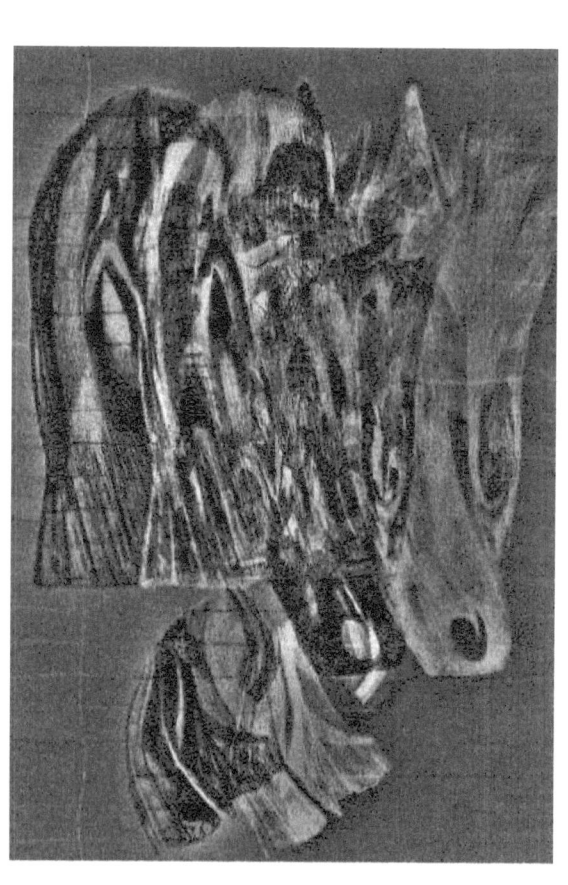

The Thumb and Doorway

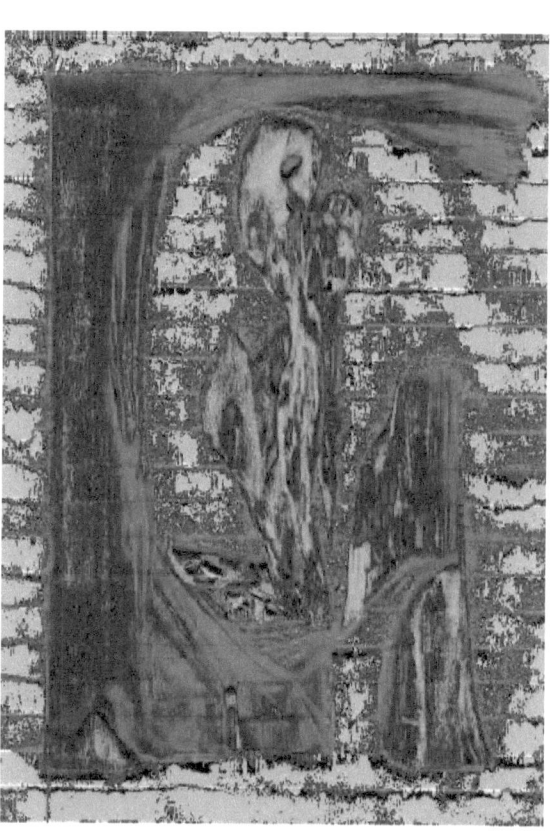

The Alien In Colors

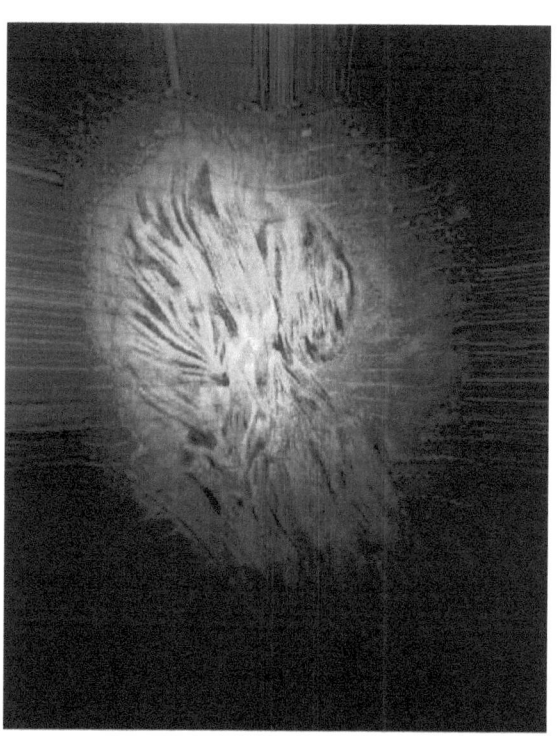

Caught By A Tiger In A Rush

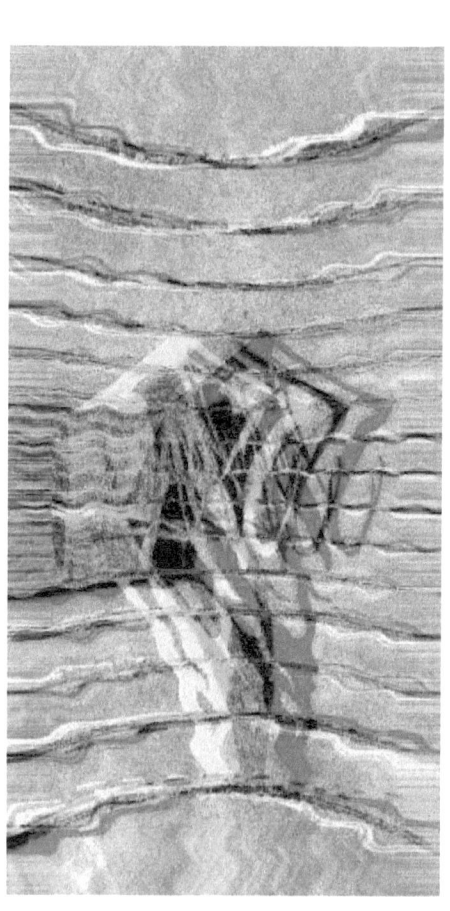

Angels Unfolding On Him

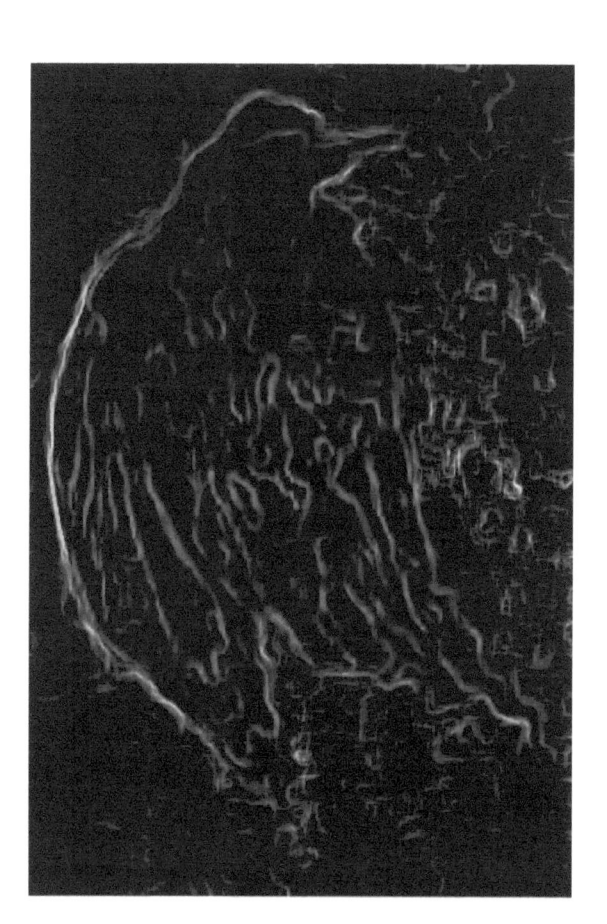

The Cloak

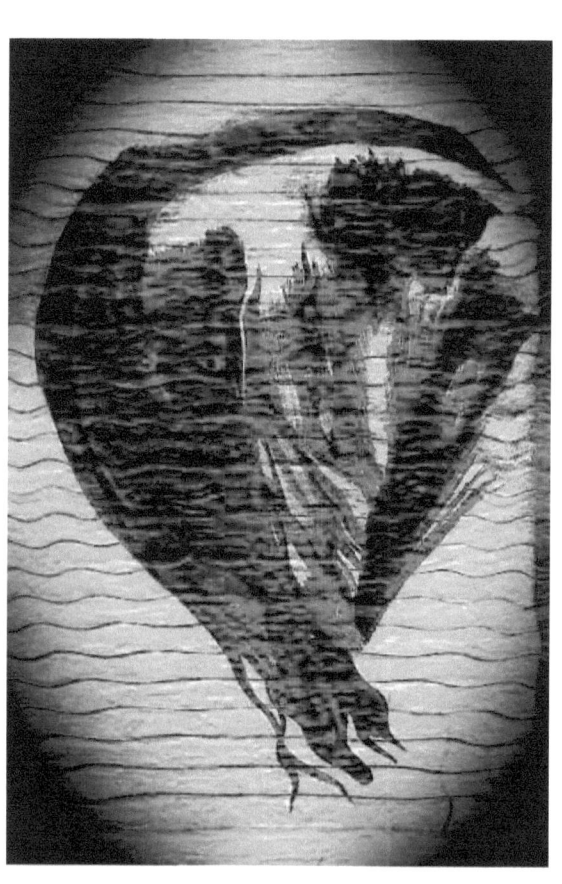

Native Feather In Blue And Red

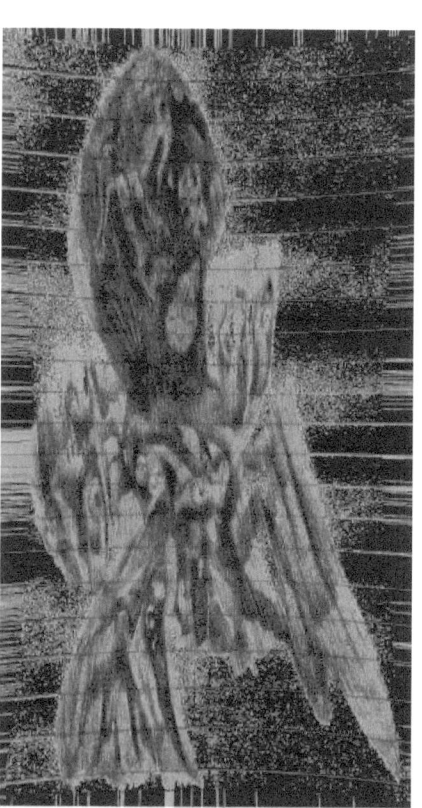

The Spider In Gauze

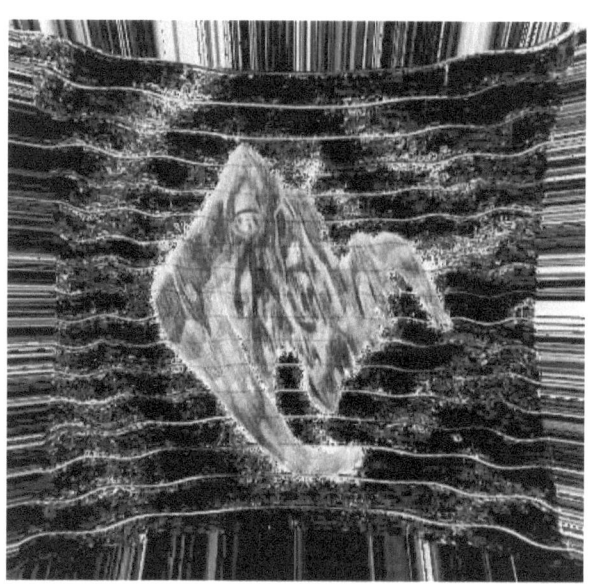

Halloween In Lights

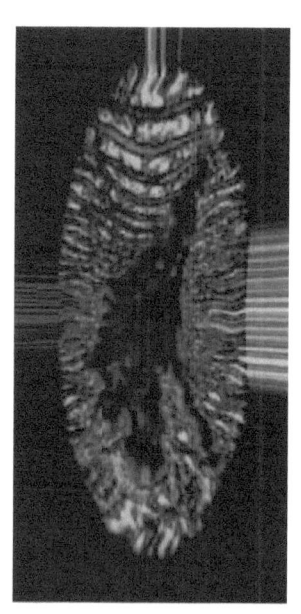

War Bonnet

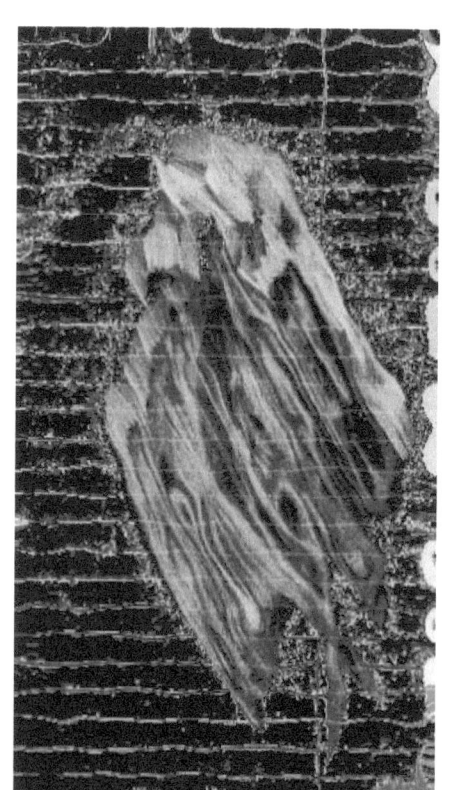

Kerchief and Scream

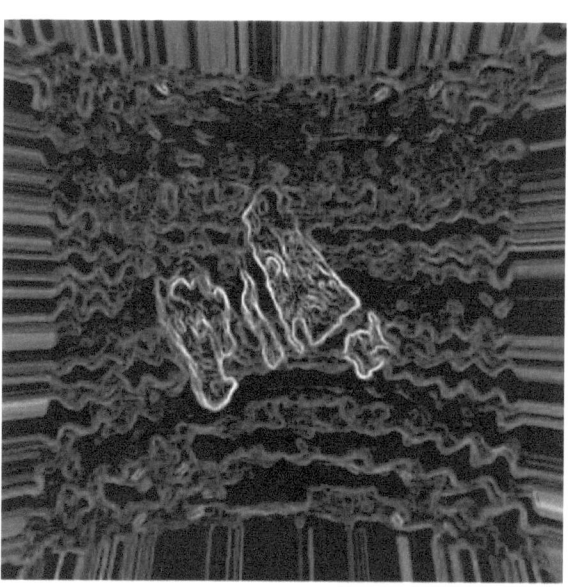

The Tiger and the Inca

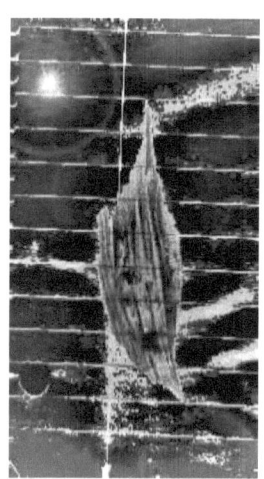

Colorful Leaf

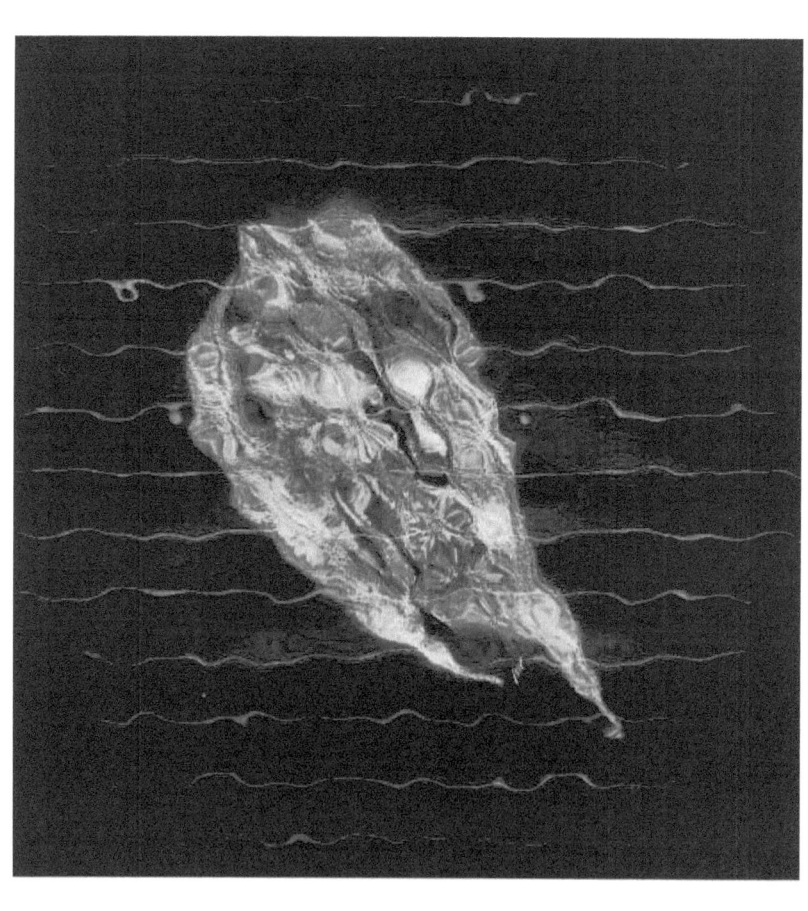

Bewildered

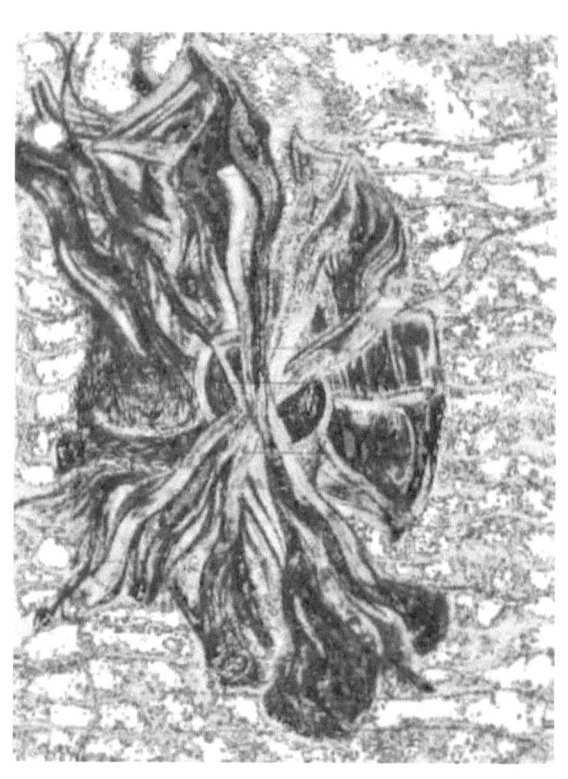

The Puzzle Picture In Flux

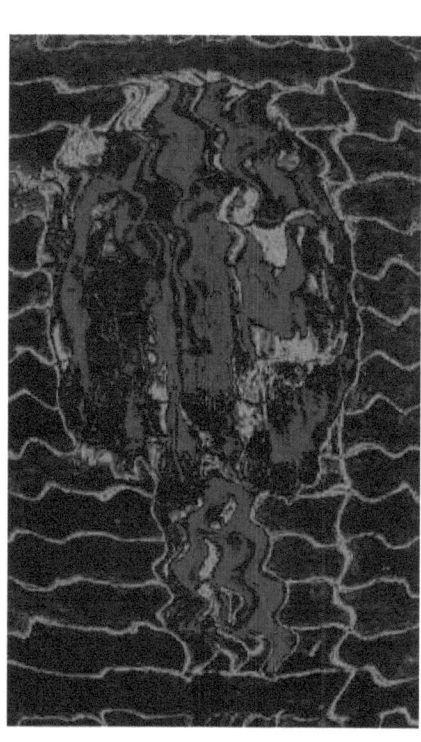

The Gnome And The Tree

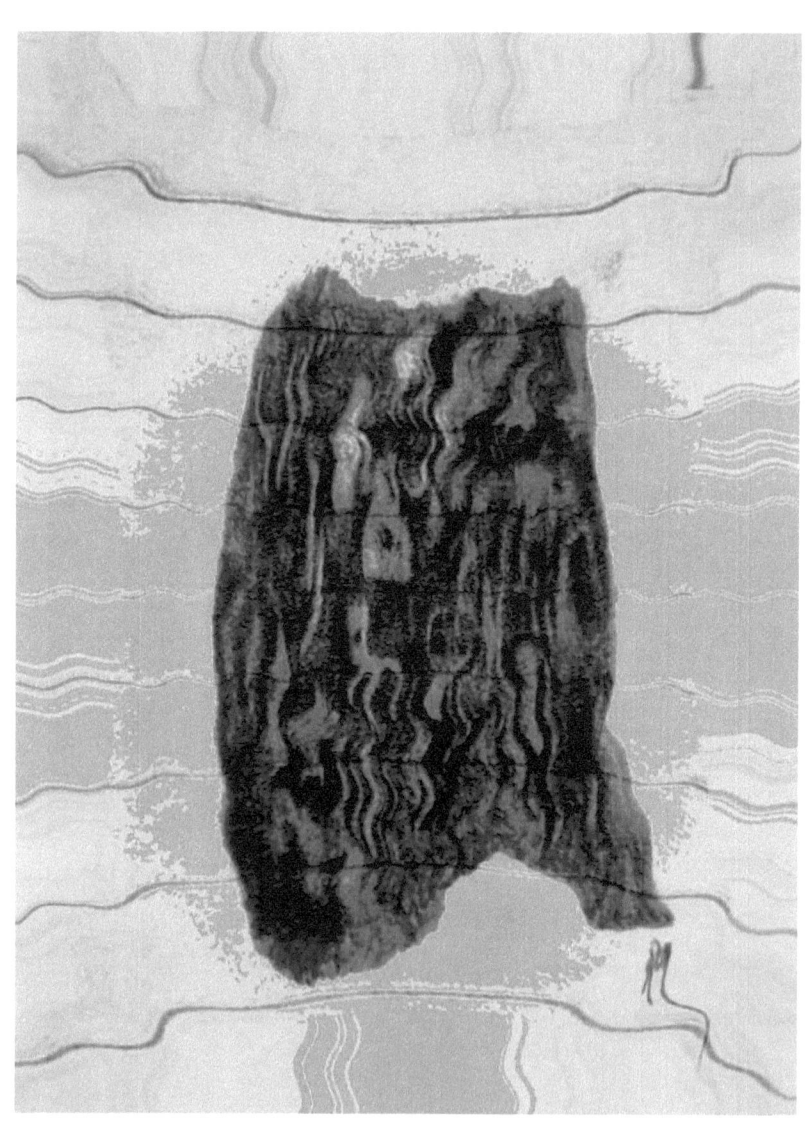

My World In Shades Of Blue

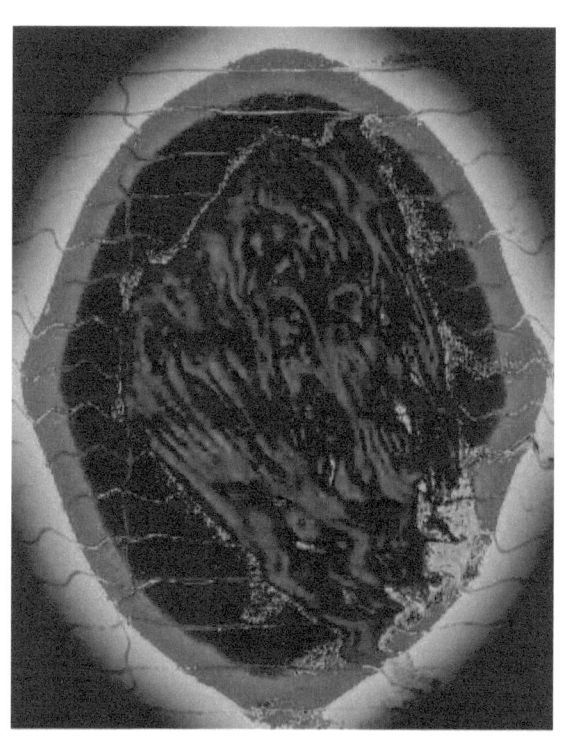

Her Visions

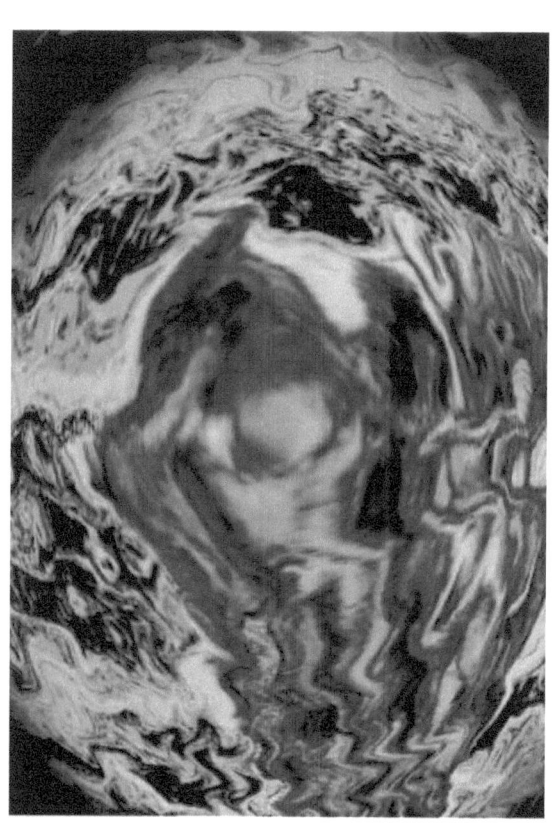

Looking From A Tempest

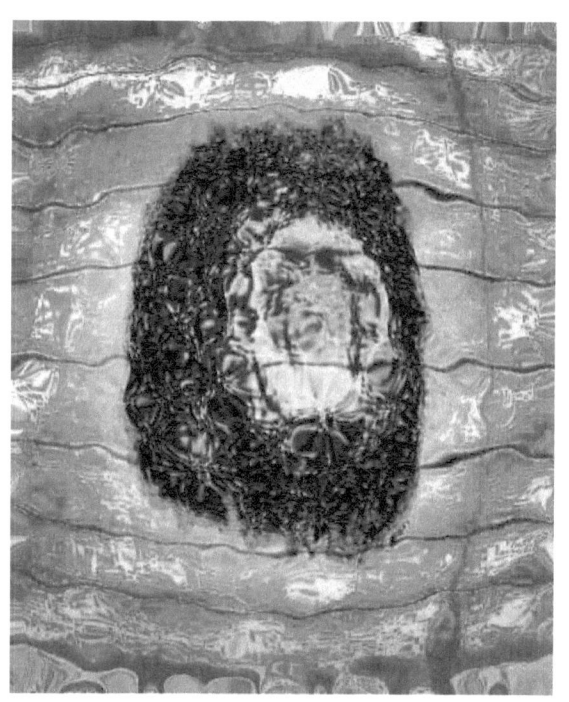

Looking Out

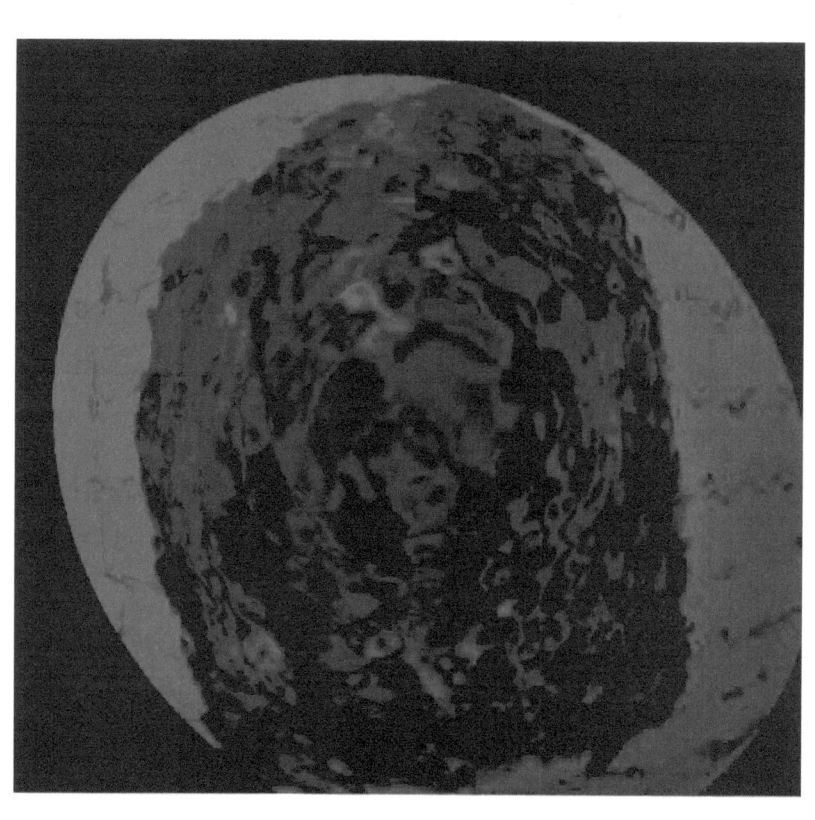

Caught In a Tempest

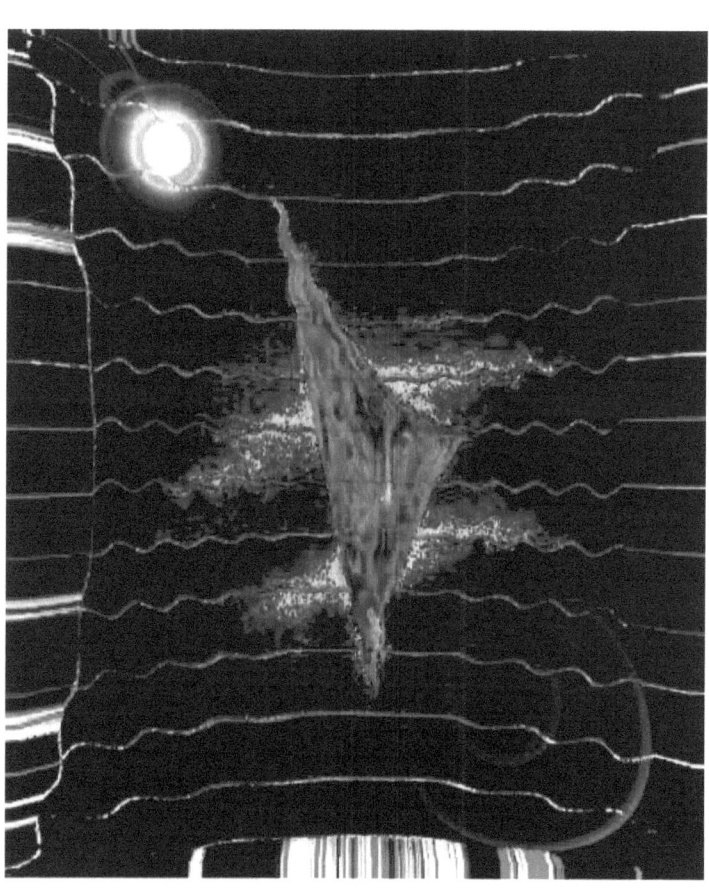

Bones And The Devil

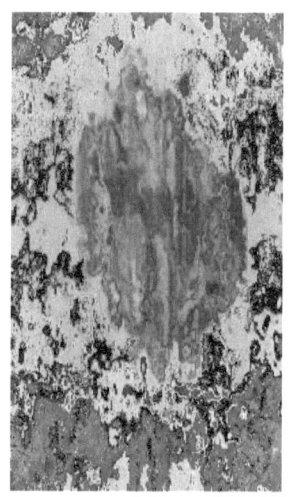

Lost Child

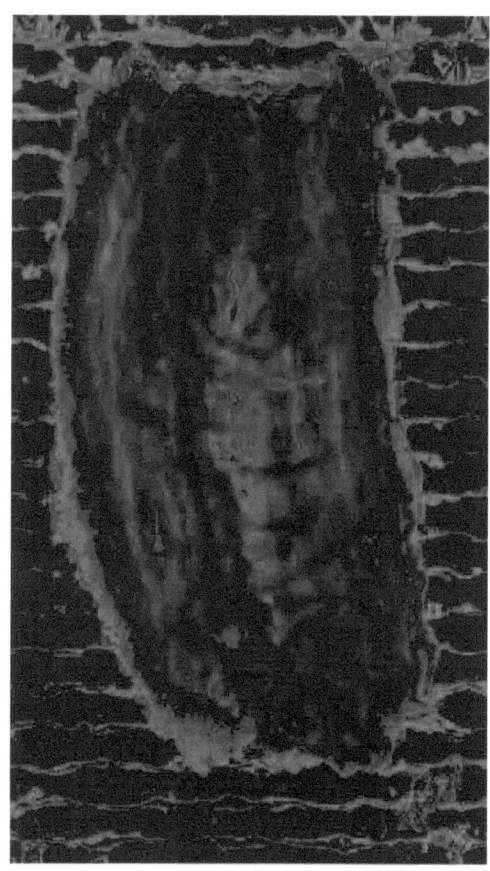

Coffin Sleep In Red

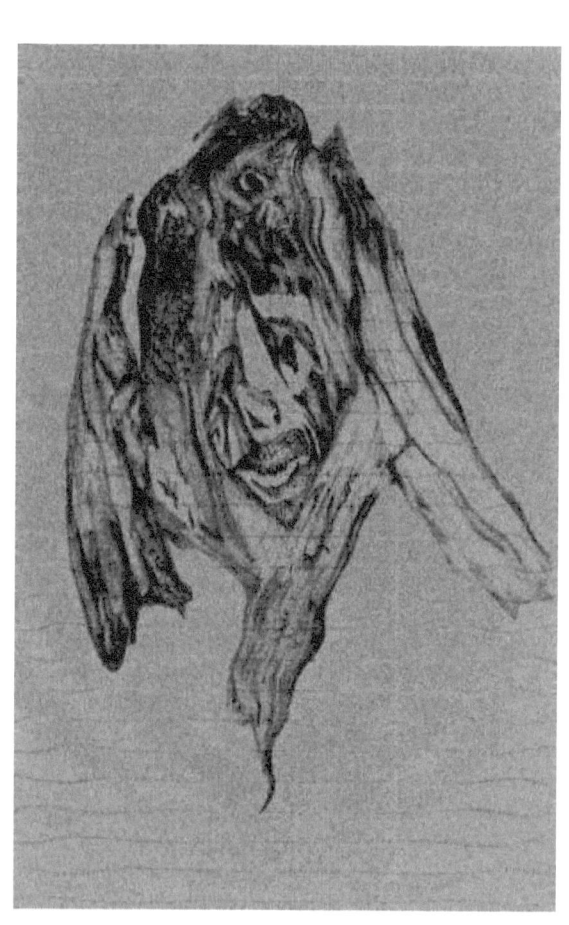

Ghostly Gray

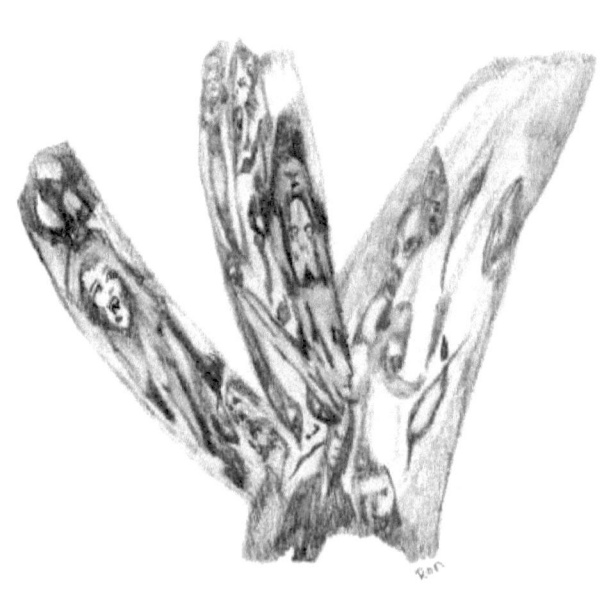

Three Paths

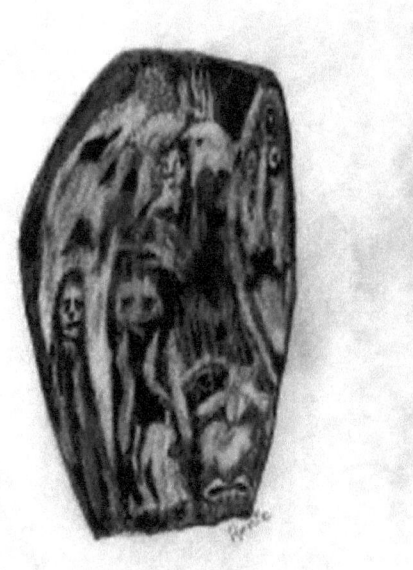

The Woods Around Me

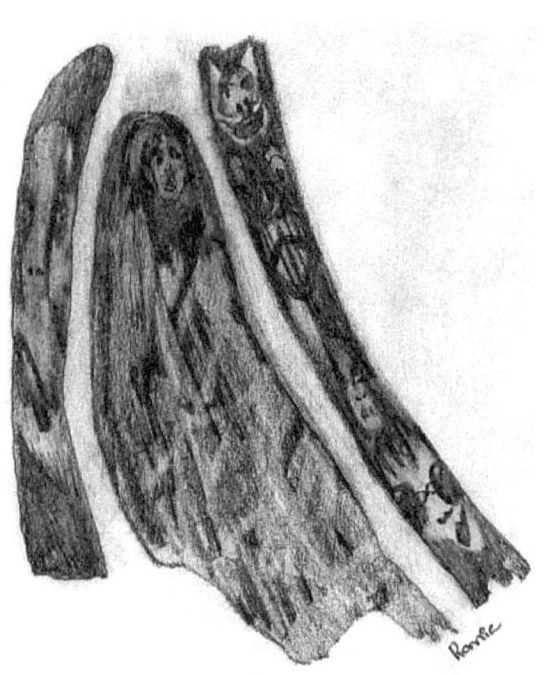

Forward and Backward

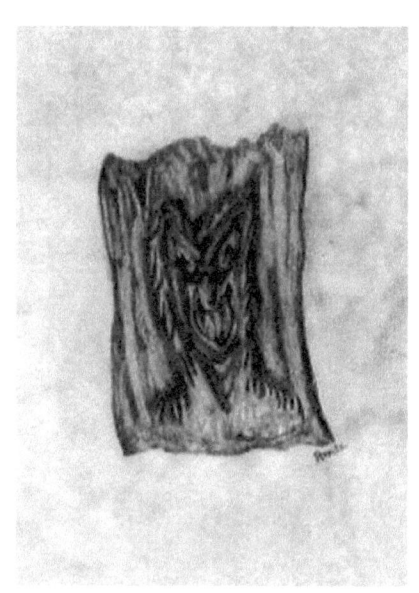

A Devil

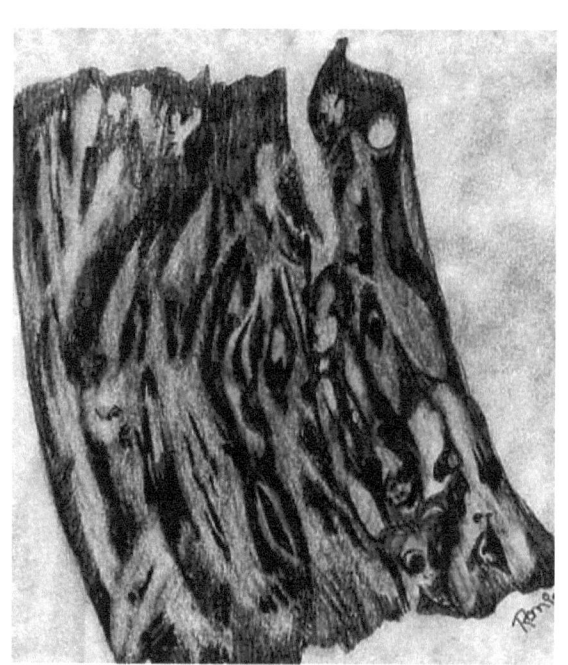

Morphing

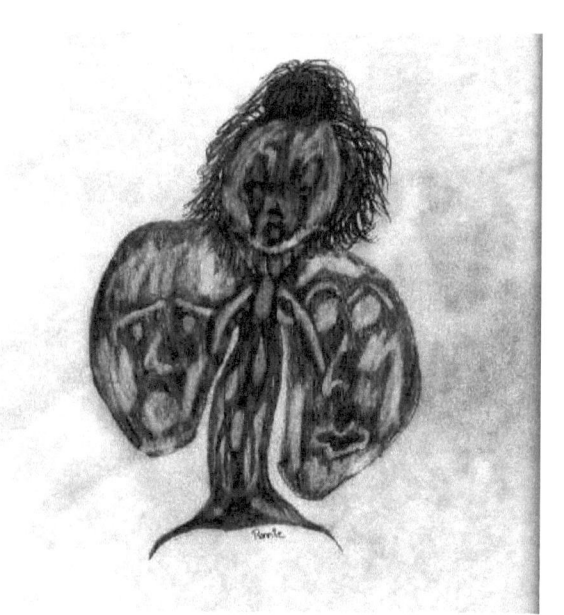

She Finds The Night

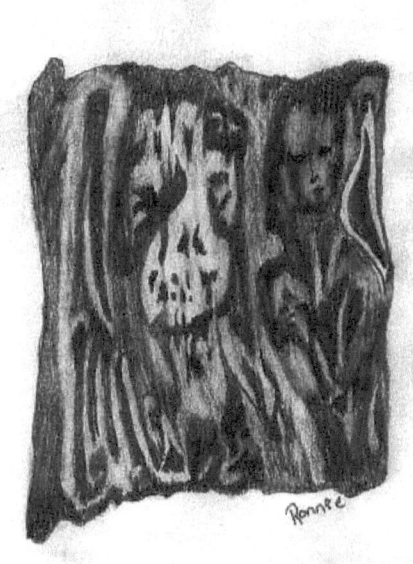

The Queen Of Shadows

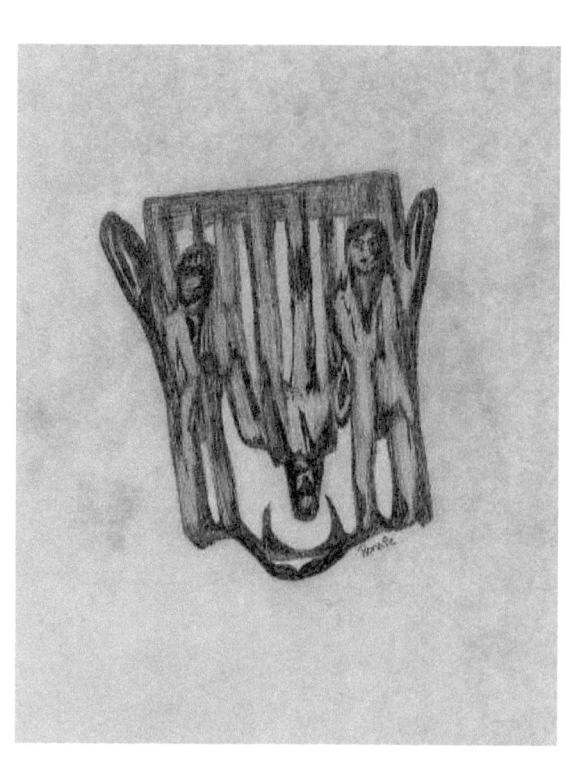

The Three

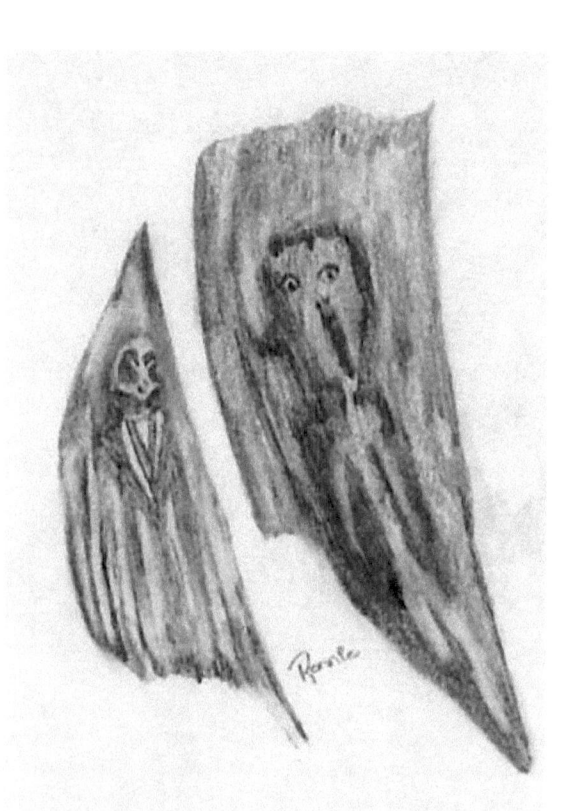

She Screams

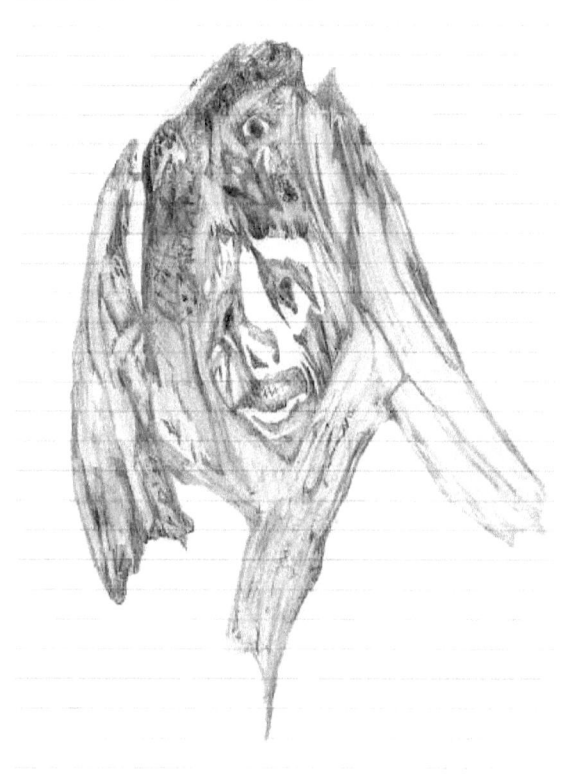

Finding The Way

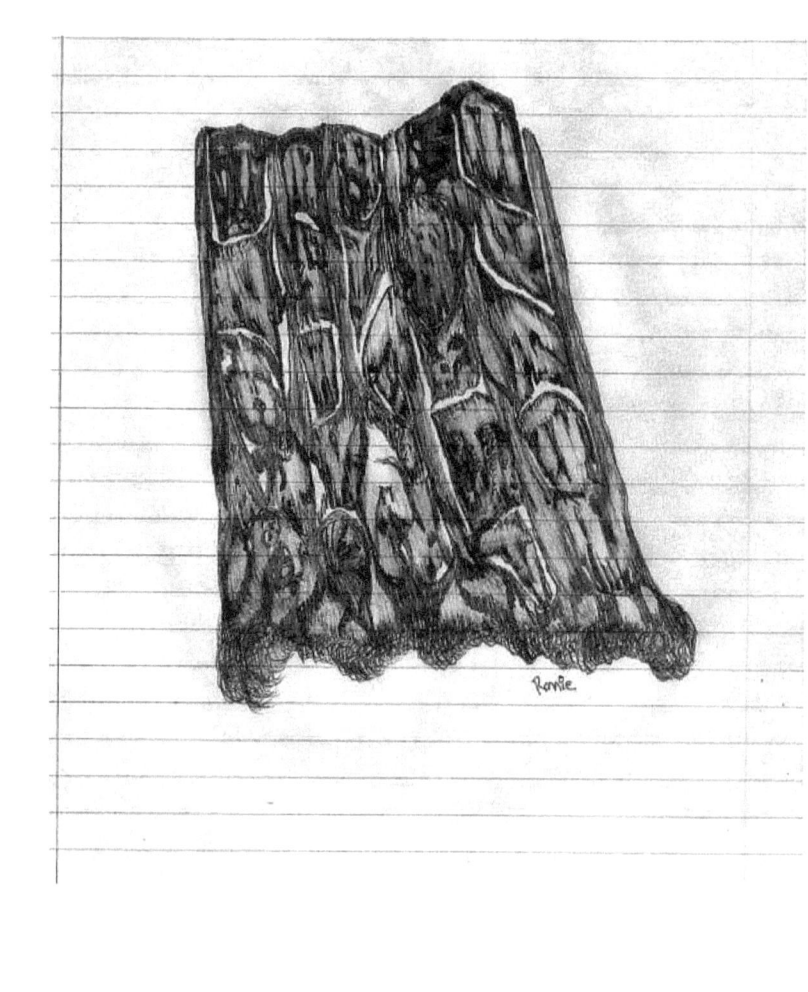

The Stump In Secret

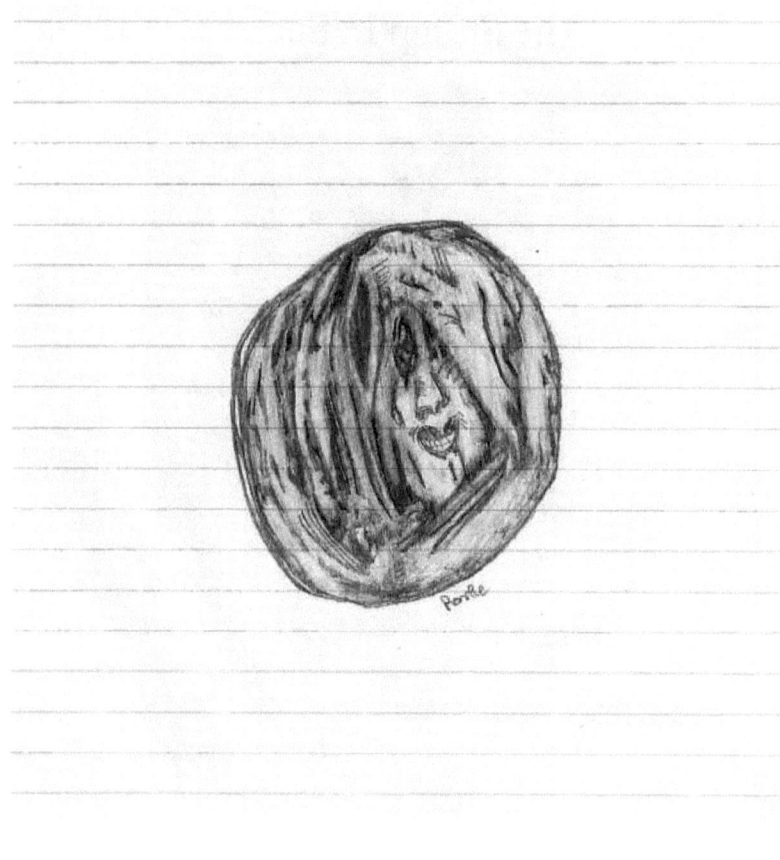

The Monk

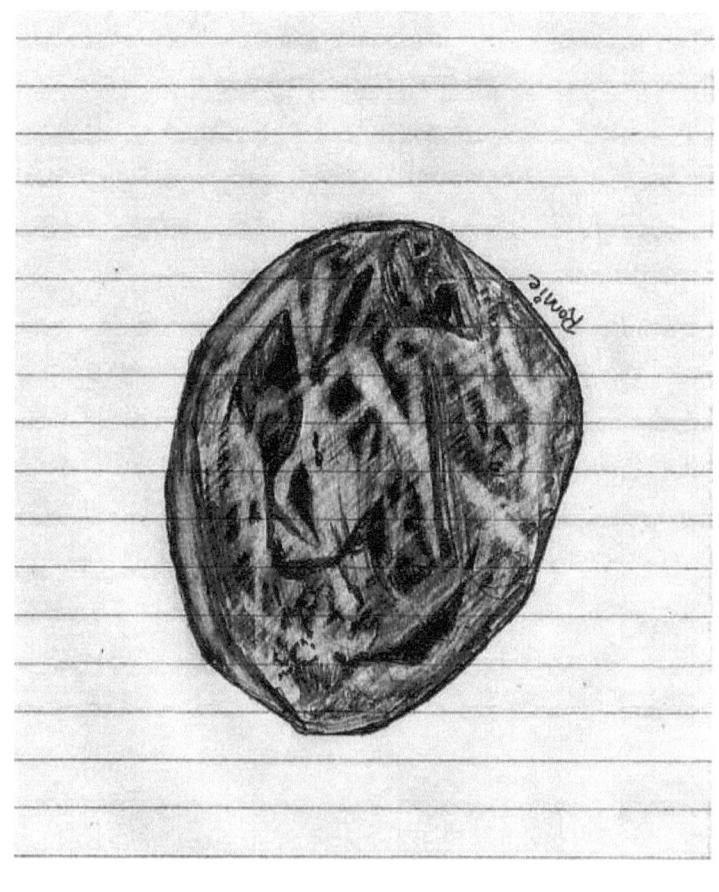

Jumbled Images of Fate

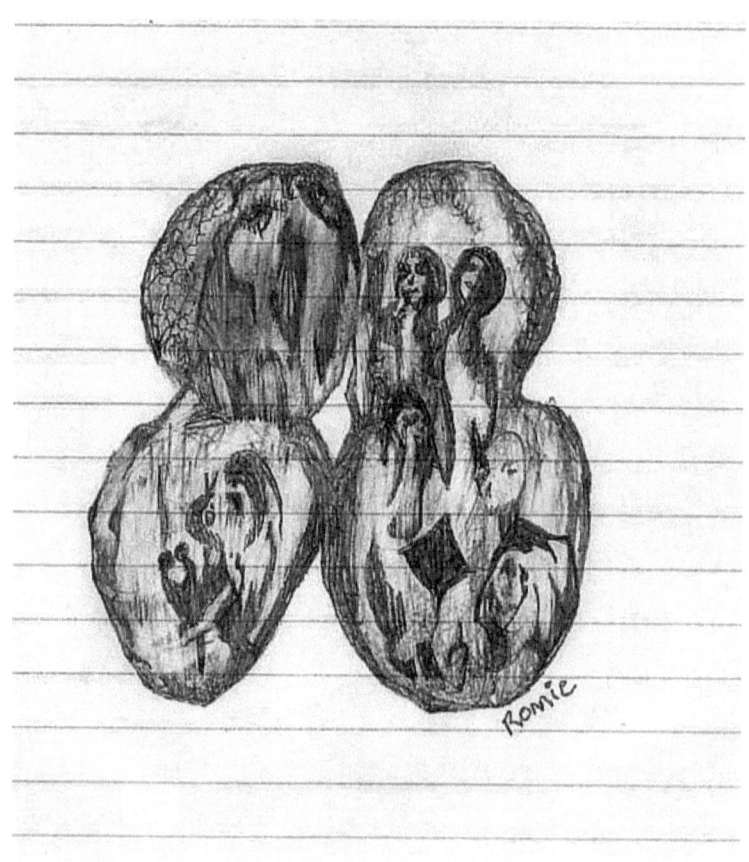

Four Globes

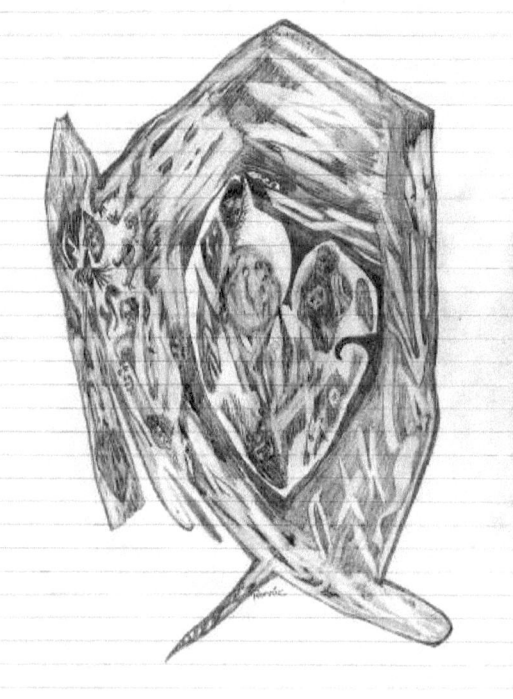

Full Circle

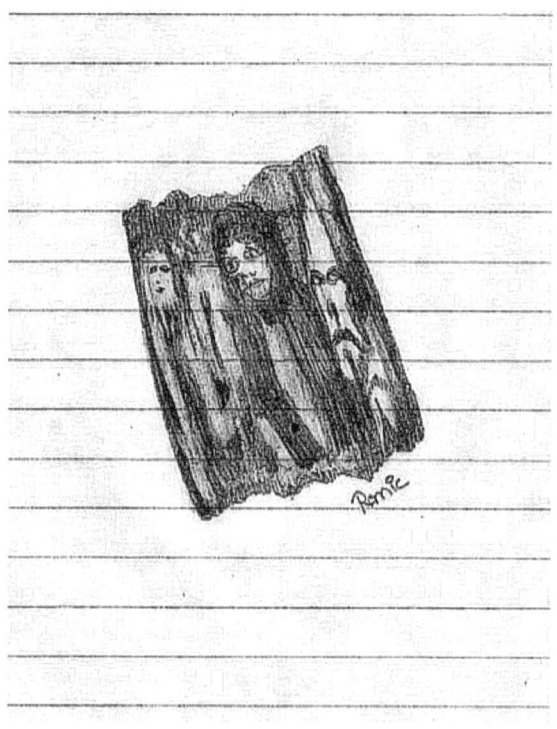

Facing The Door

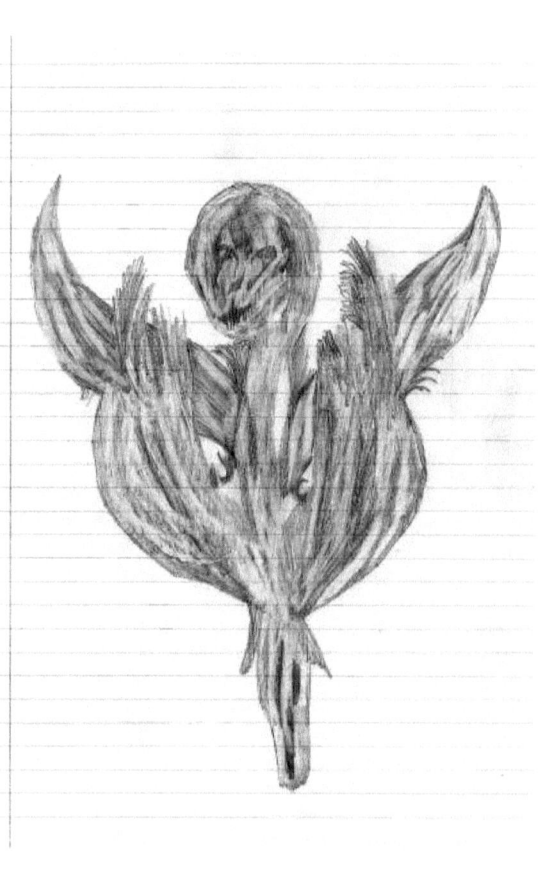

The Bird

Ghosts

Jus Passin Through

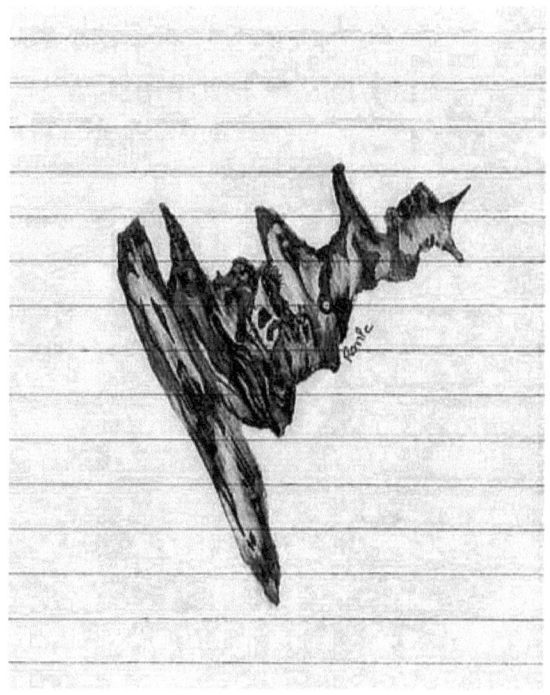

Segmented

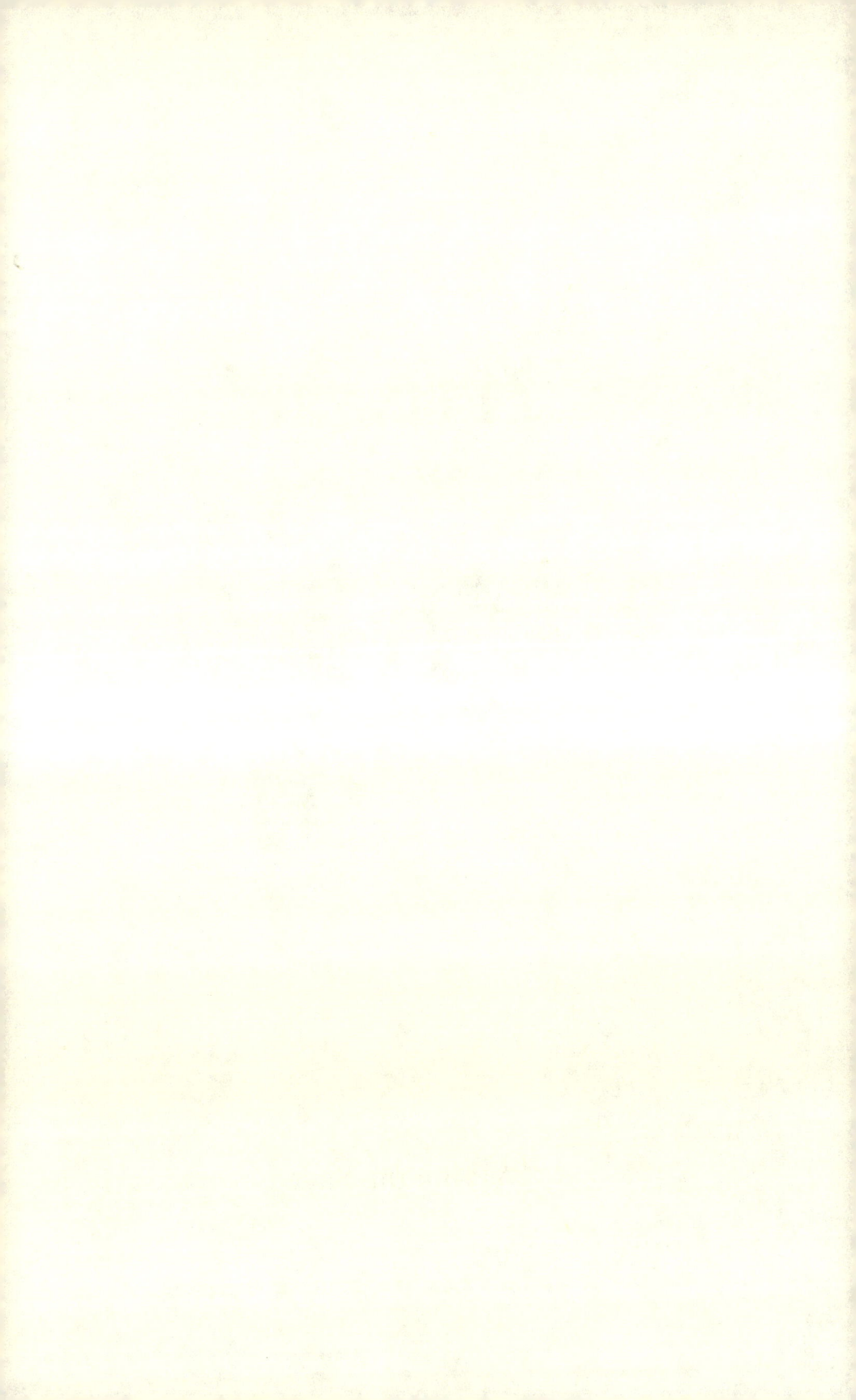

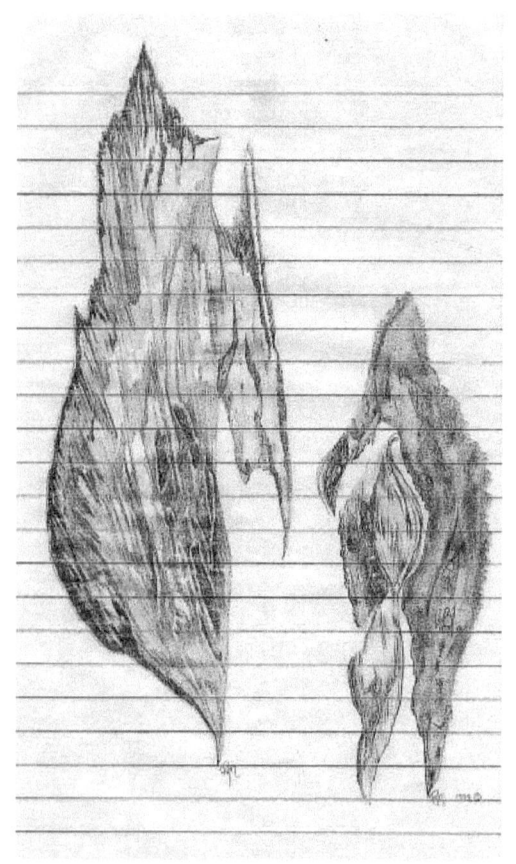

Asking the Sage

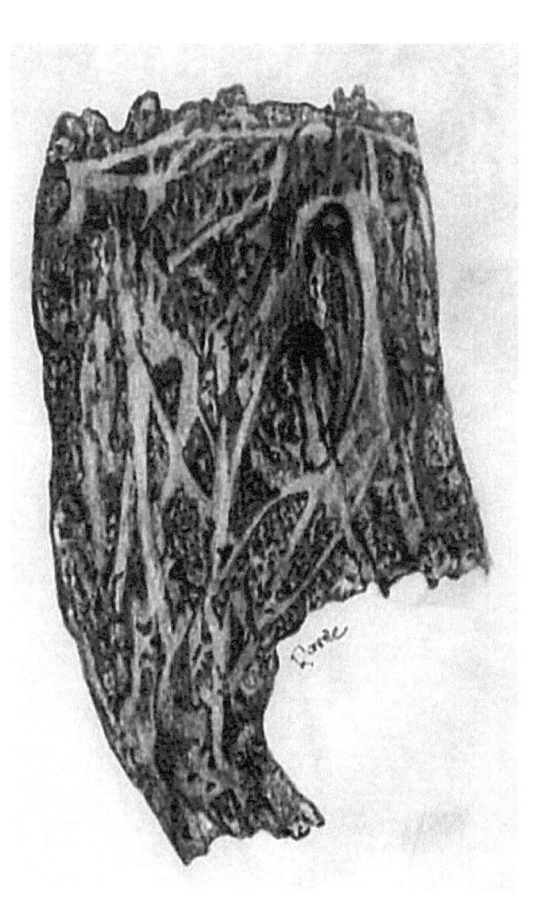

Metamorphosis

The Mummy

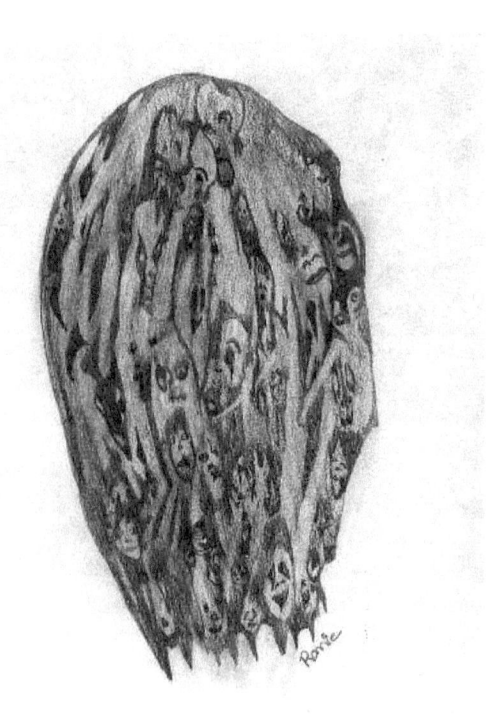

Hidden Wonder

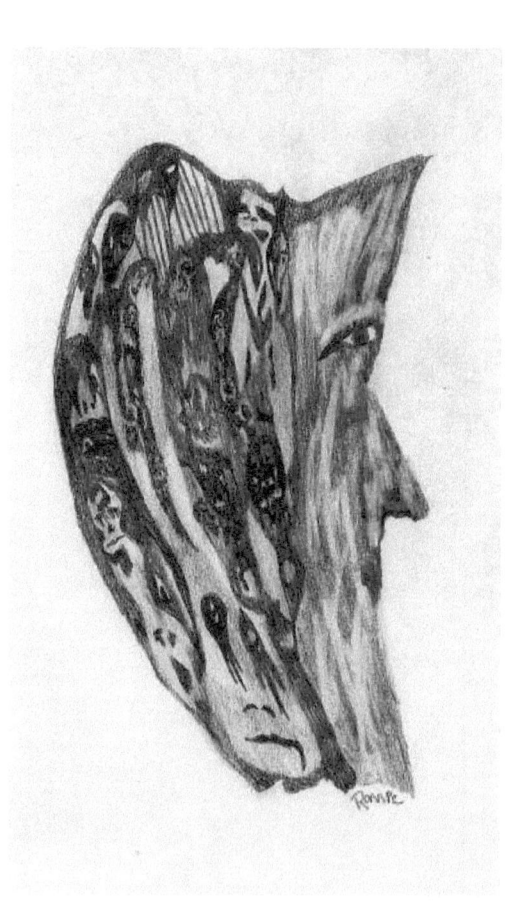

In His Head

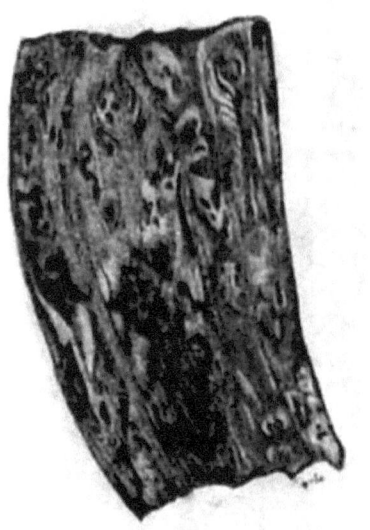

Clouds of Color

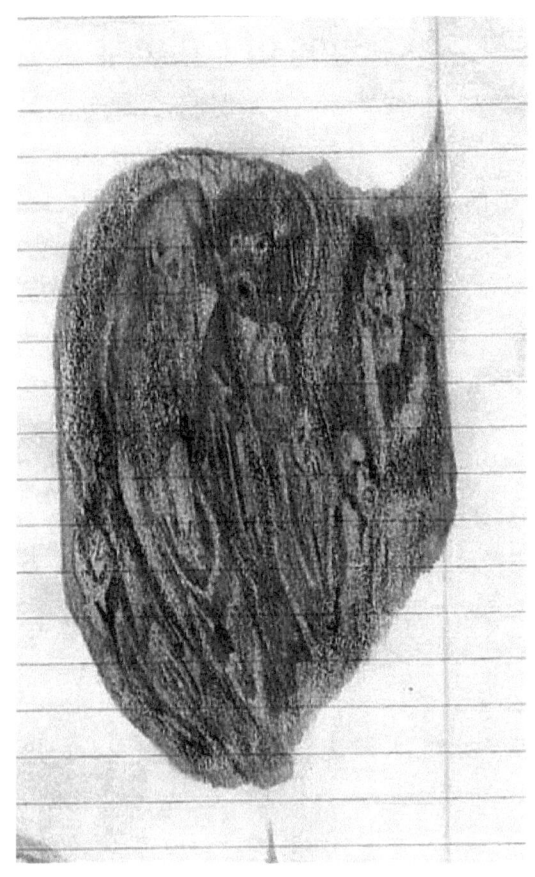

Reflections In Blue

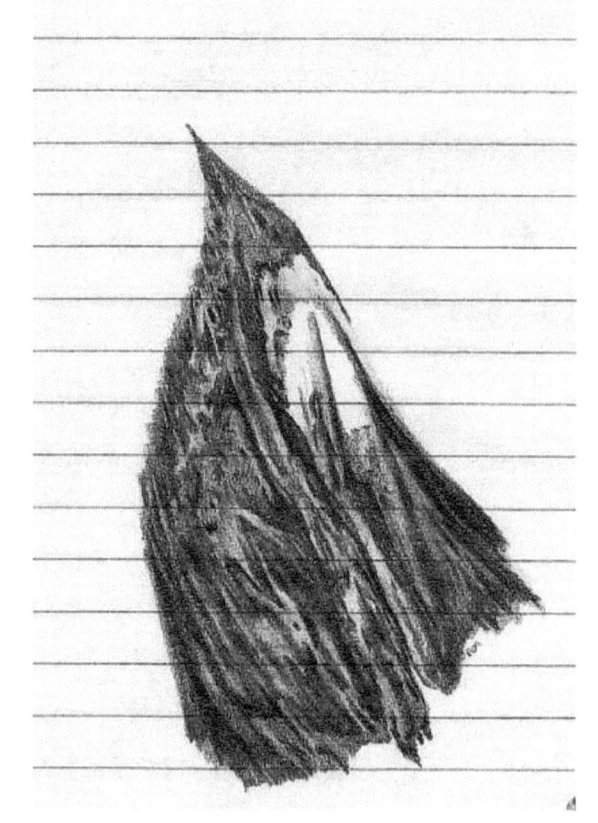

The One Who Watched

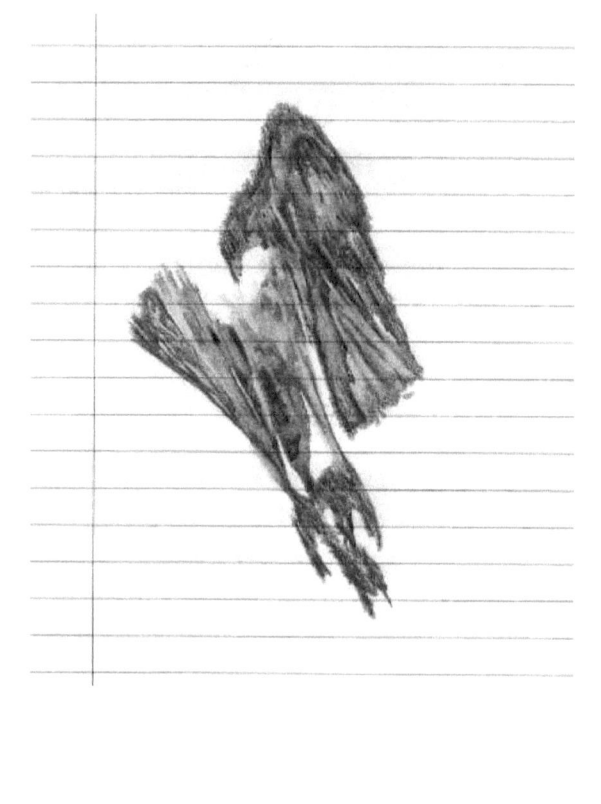

Porky Gets Scared

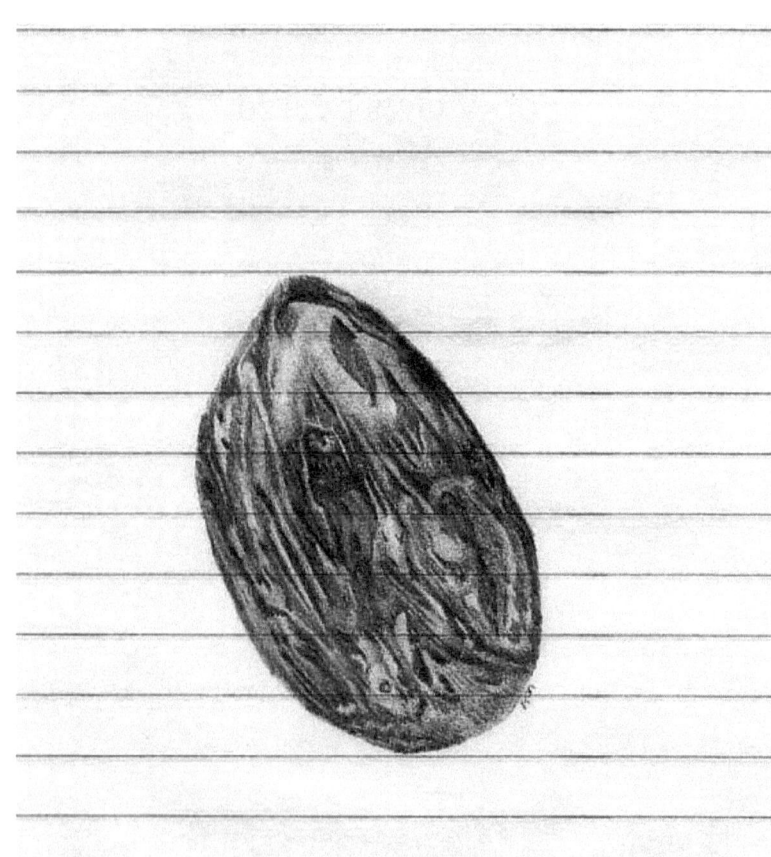

Looking Glass

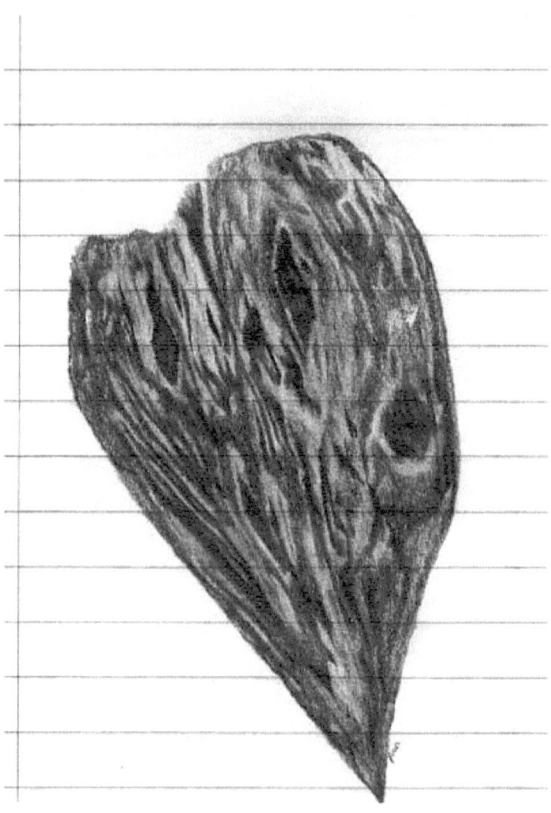

Full Speed

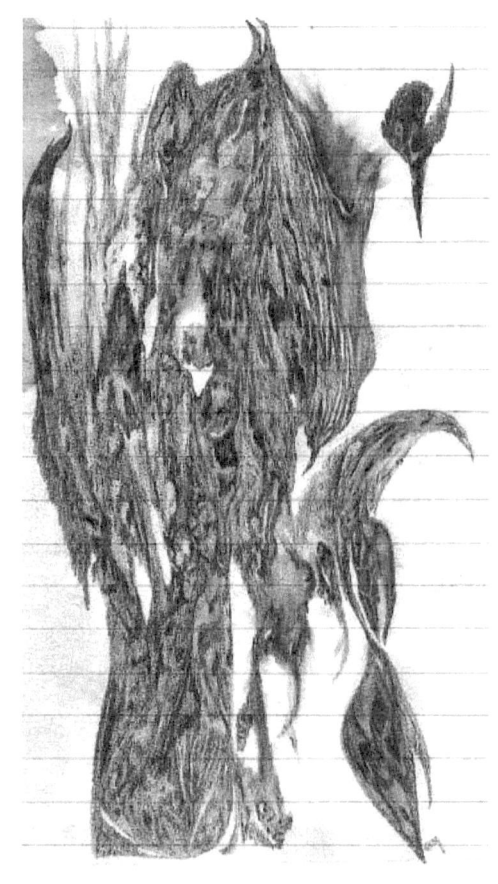

On The Wings Of A Dragon

An Angel

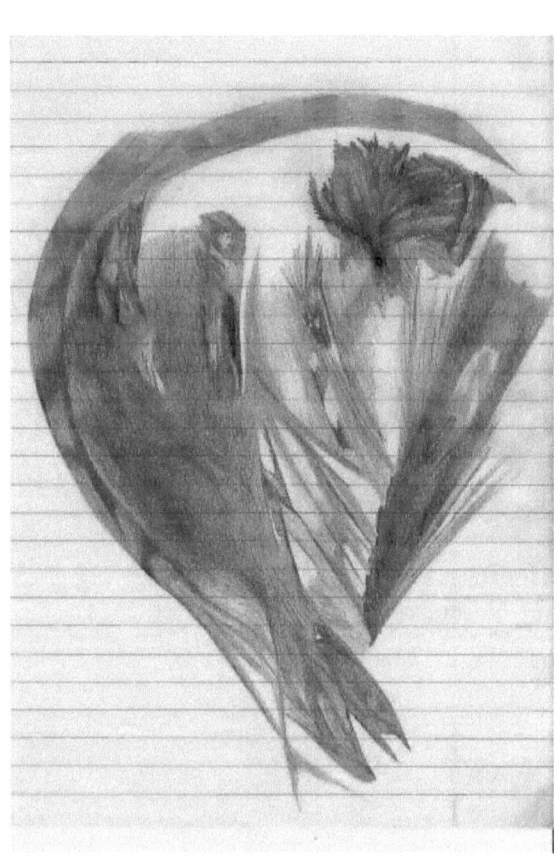

Native Feather

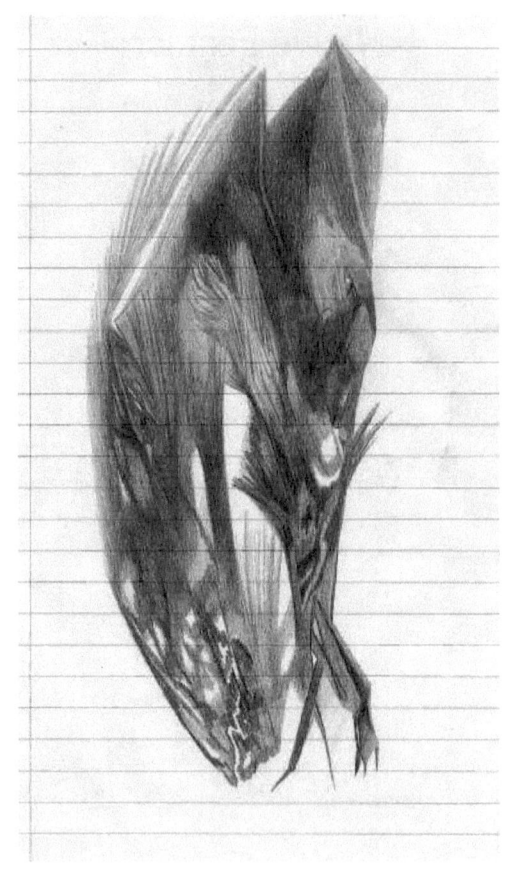

Witch Doctor

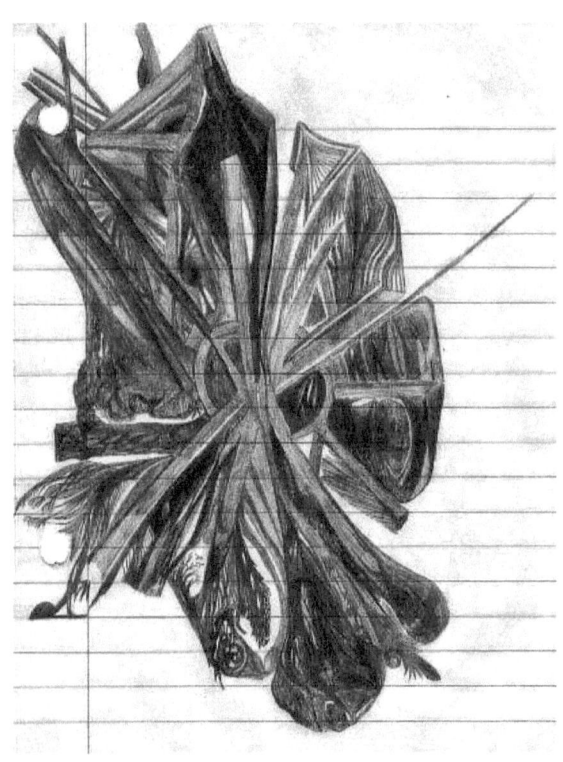

The Puzzle Picture

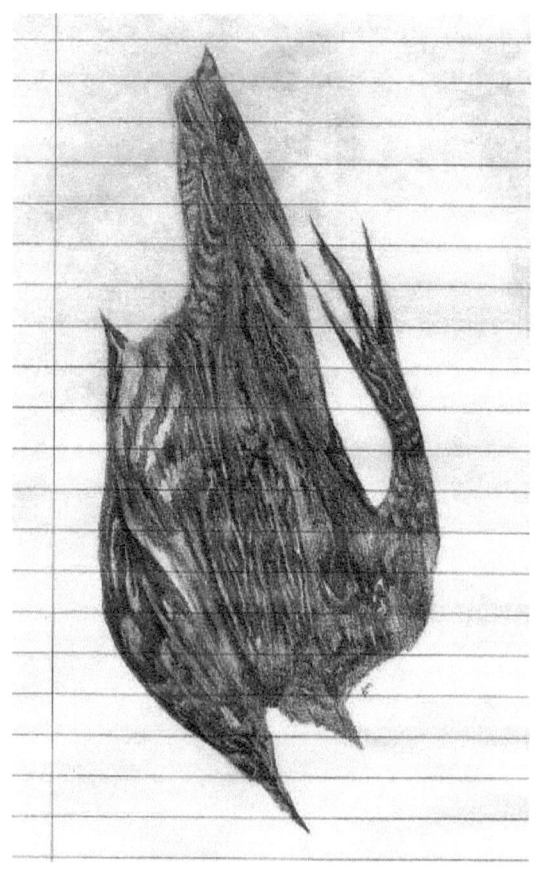

Alien Three

The Cat

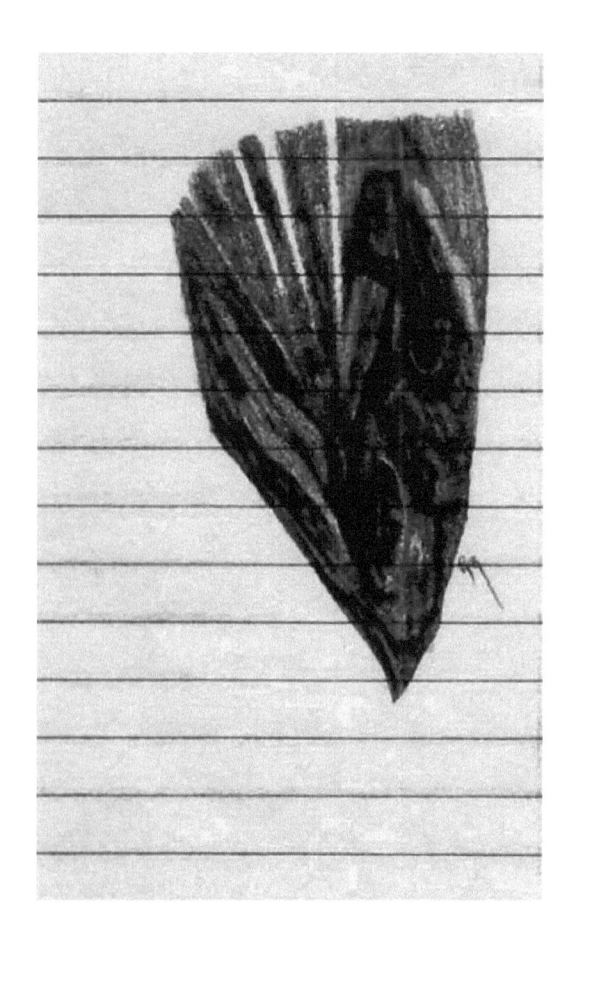

The Knife Cut

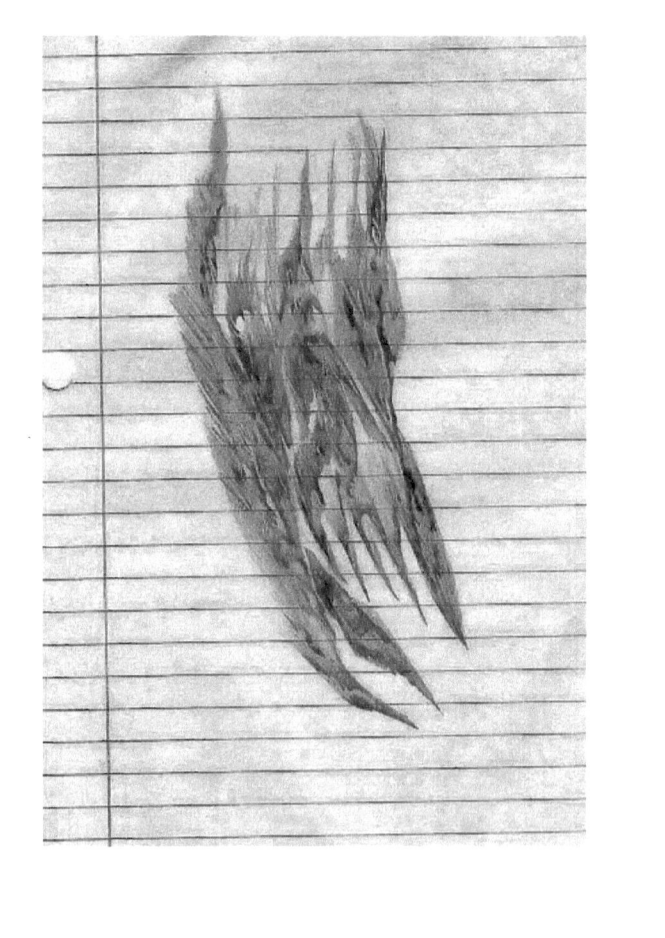

Feathered Dragon

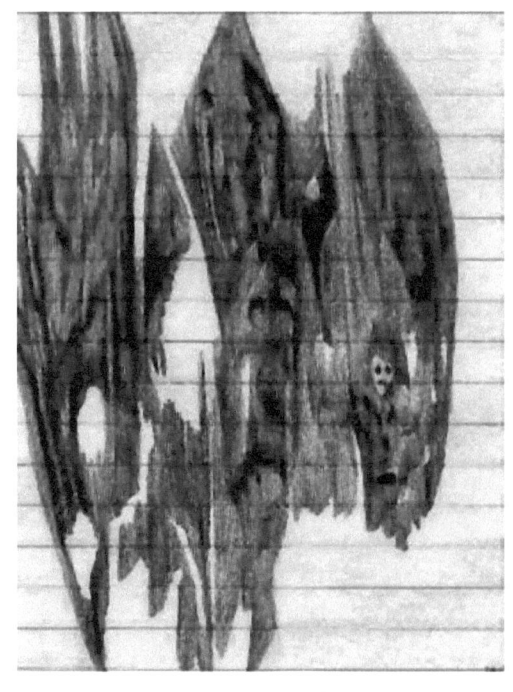

Hidden In Darkness

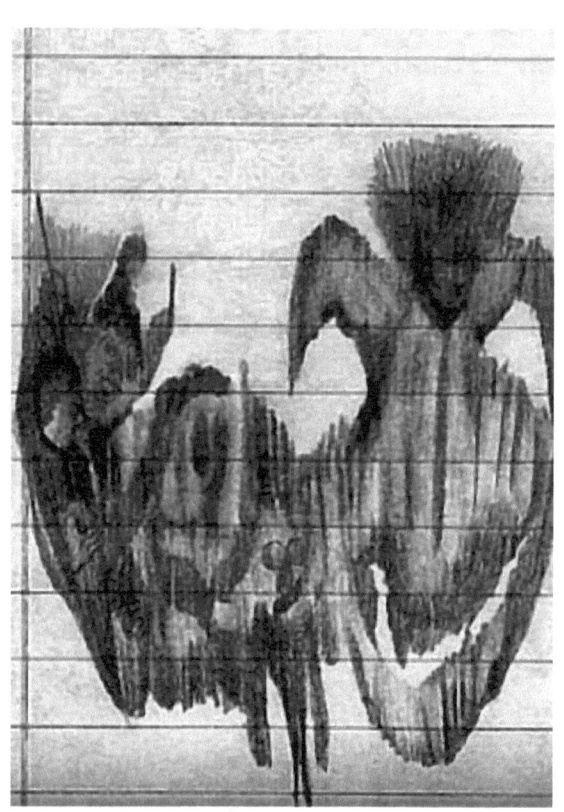

Comedy Vs. Tragedy

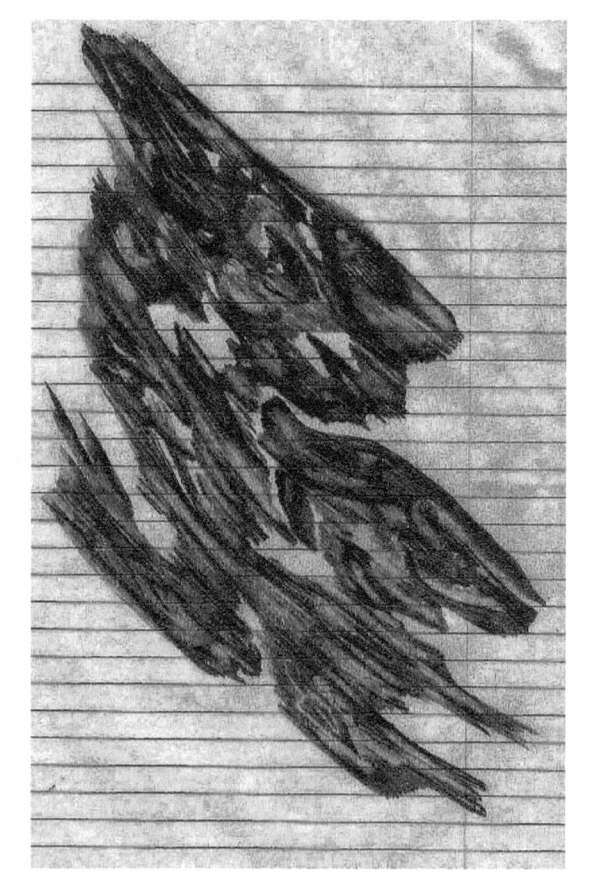

Extra Terrestrial

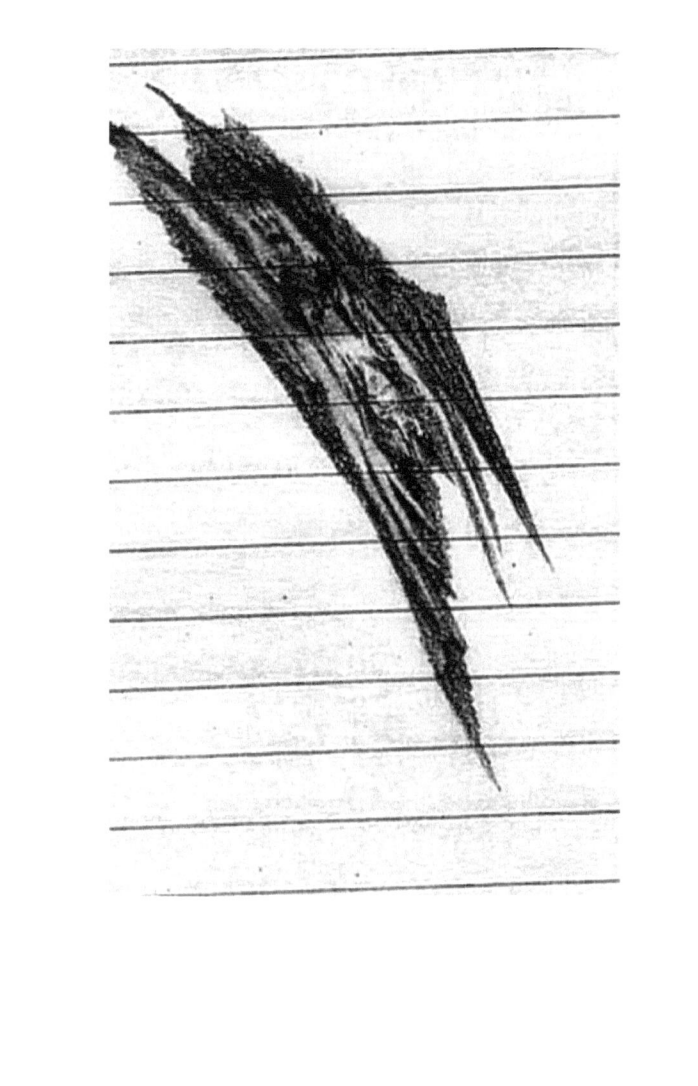

Queen Of The Butterflies

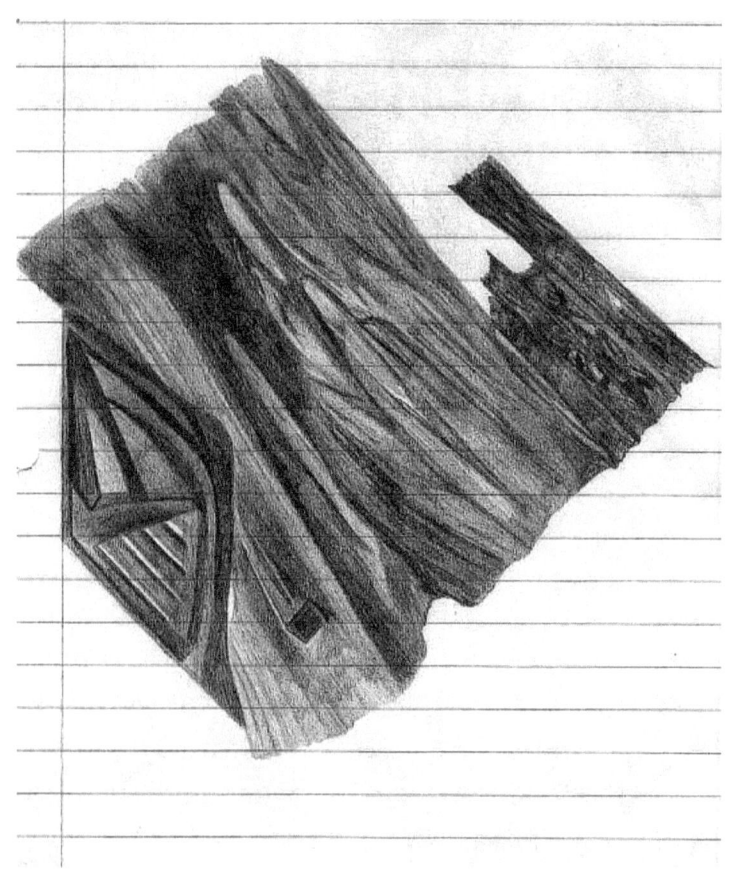

Lost Images of a Family

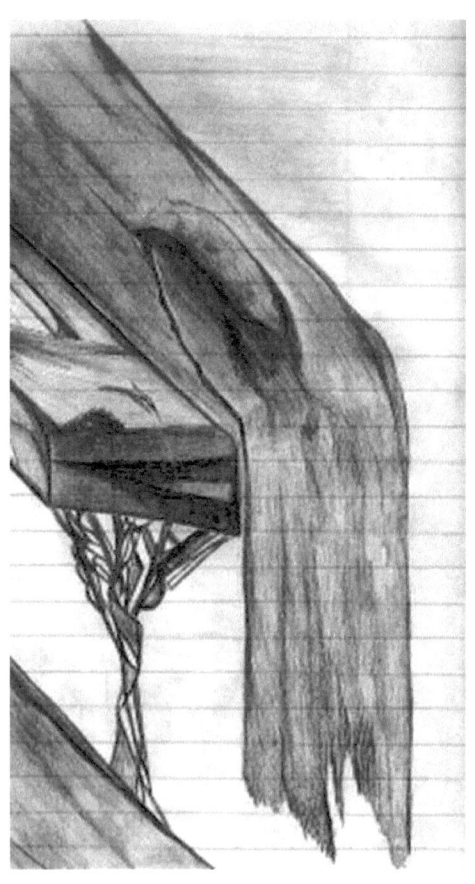

Wood Melting

Hung

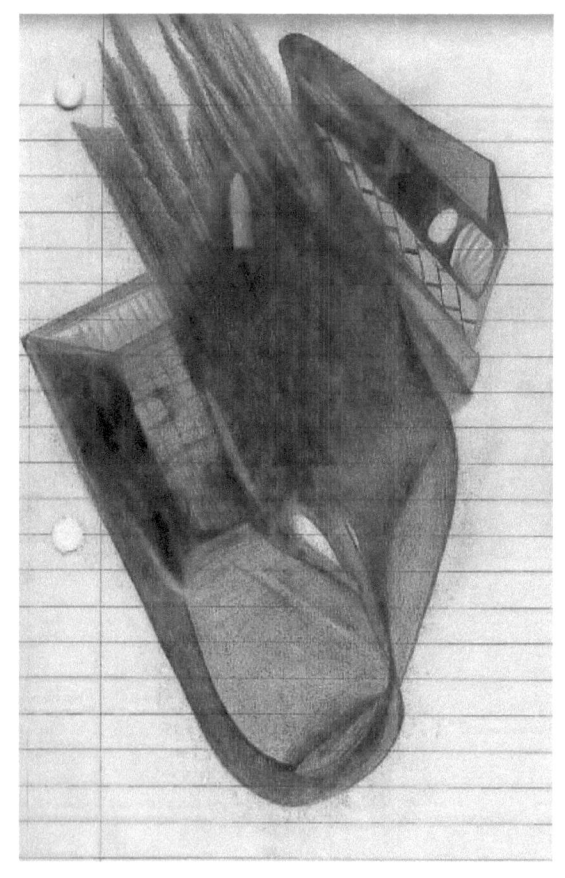

Oppression

The Shaman

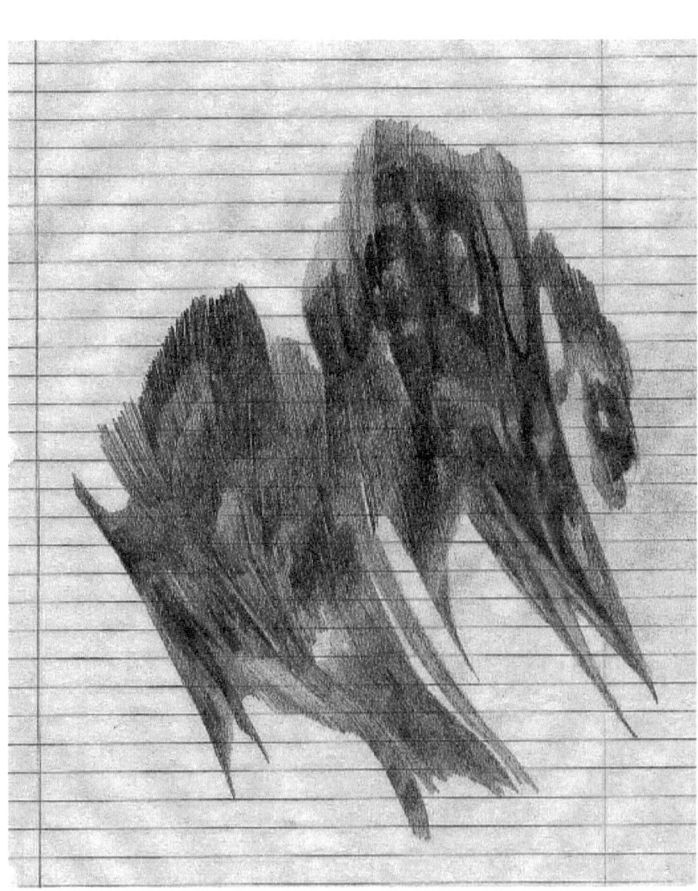

A lien Encounters

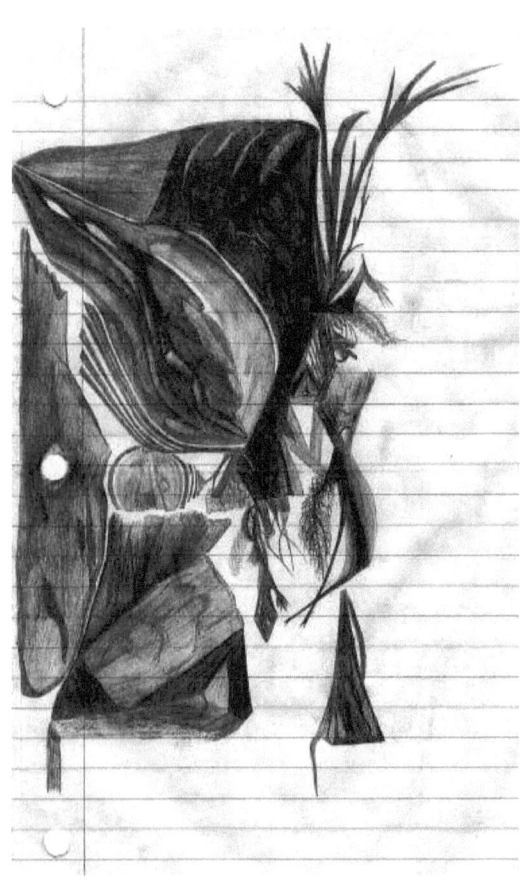

The Swamp

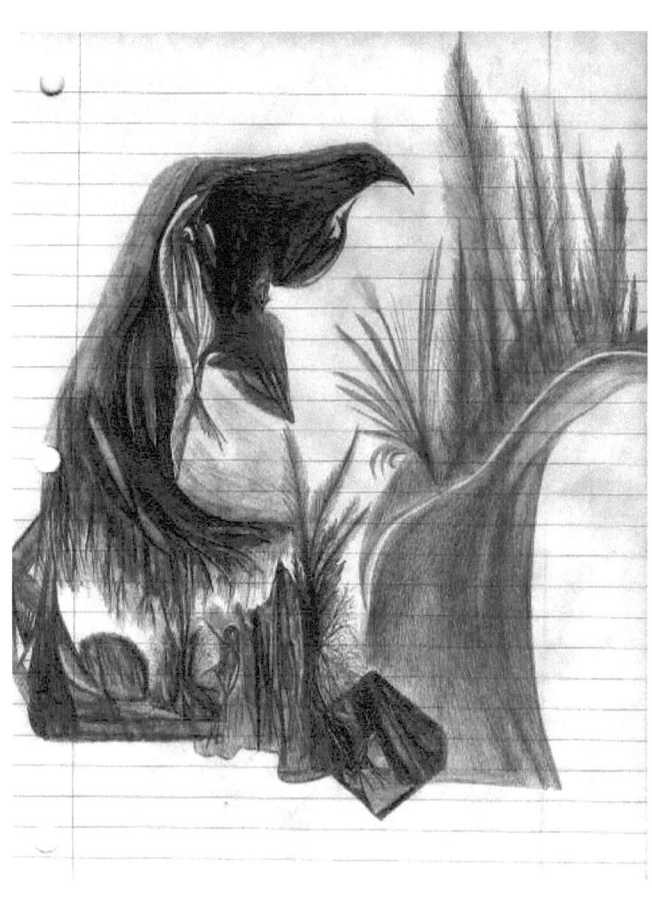

A Crow

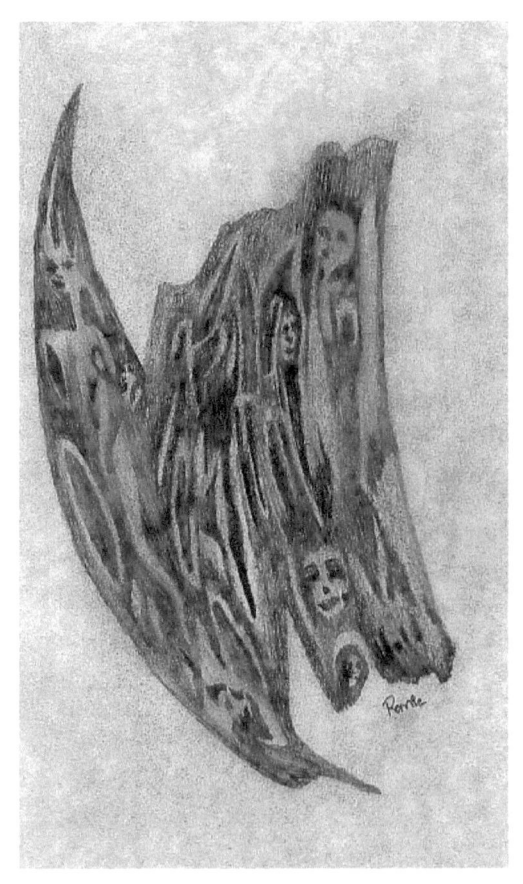

Hallow Looks

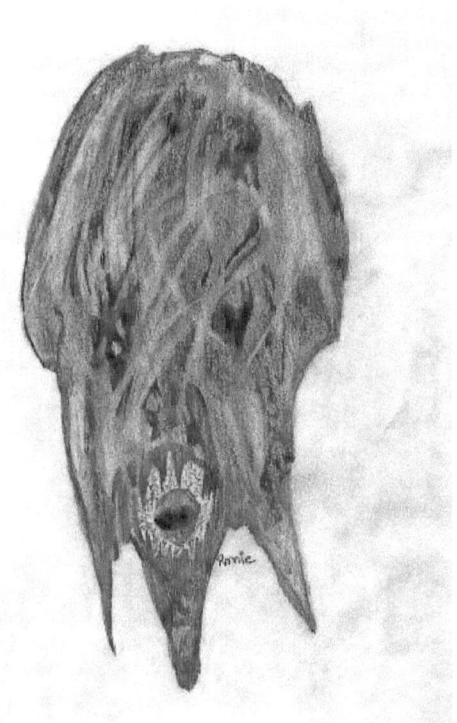

Looking Out

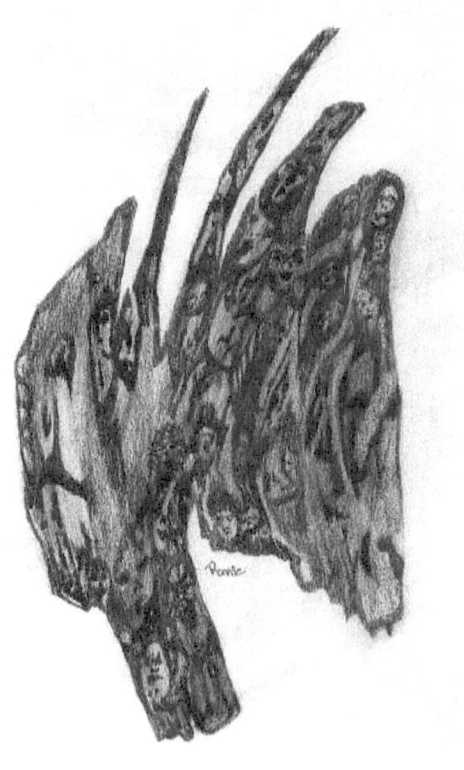

Butterfly Dreams

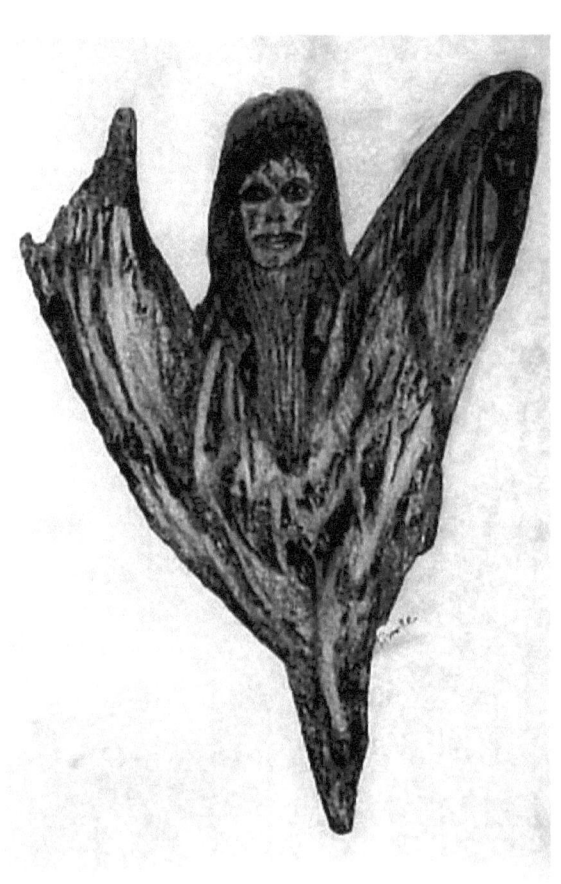

The Moth

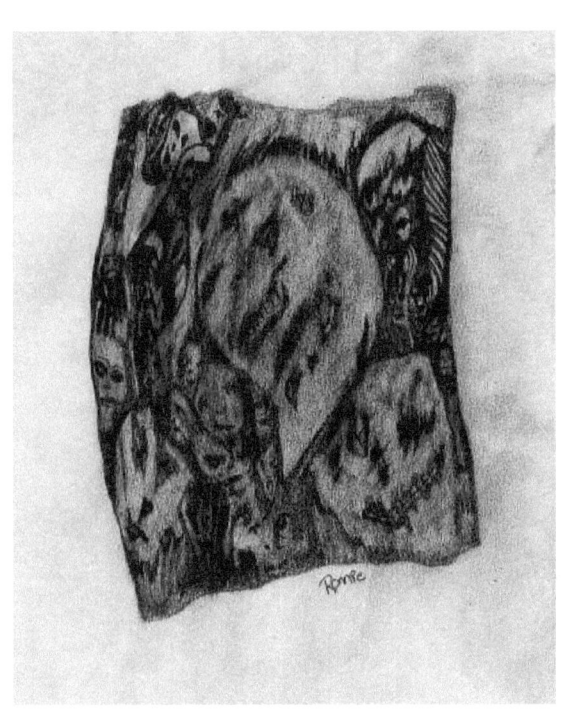

Zombie Dreams

Thank You

www.ingramcontent.com/pod-product-compliance
Lightning Source LLC
Chambersburg PA
CBHW031837170526
45157CB00001B/332